IMAGES
of America

FILIPINOS IN
SAN FRANCISCO

ON THE COVER: The Filipino community of San Francisco has participated in various civic events including the Columbus Day Parade, shown here in 1952. Leading the caravan are, from left to right, Celestino Alfafara (grandmaster of the Caballeros Dimas Alang), Rhoda Buted, Juanita Cayton Alfafara, Adele Bautista, and Fred Carino. The driver is unknown. (Courtesy of Adele Urbiztondo.)

IMAGES
of America

FILIPINOS IN
SAN FRANCISCO

Filipino American National Historical Society,
Manilatown Heritage Foundation, and
Pin@y Educational Partnerships

ARCADIA
PUBLISHING

Copyright © 2011 by Filipino American National Historical Society, Manilatown Heritage Foundation, and Pin@y Educational Partnerships

ISBN 978-0-7385-8131-6

Published by Arcadia Publishing
Charleston, South Carolina

Printed in the United States of America

Library of Congress Control Number: 2010929266

For all general information, please contact Arcadia Publishing:
Telephone 843-853-2070
Fax 843-853-0044
E-mail sales@arcadiapublishing.com
For customer service and orders:
Toll-Free 1-888-313-2665

Visit us on the Internet at www.arcadiapublishing.com

This book is dedicated to Victoria Manalo Draves, a Pinay daughter from South of Market, who passed away on April 11, 2010. In 1948, she won two Olympic gold medals, and she continued to mentor young athletes. A park located at Folsom and Sherman Streets in the South of Market neighborhood where she grew up is named in her honor.

CONTENTS

ACKNOWLEDGMENTS

We express our profound gratitude to the kind donors of photographs, documents, and oral histories that are the reason-for-being of this collaborative project.

More than 100 individuals, families, archives, and organizations credited in the captions contributed material, including many cherished and irreplaceable heirlooms, to this photographic journal. We apologize to those generous people whose images we were unable to include because of the publishing limitations of the project. The editorial committee is deeply appreciative of their time, energy, and firm commitment to the preservation of Filipino American history in San Francisco.

Many volunteers and interns performed a broad array of tasks to assist the editorial committee: historical research, image scanning, digital photograph processing, and photography. Our volunteers and interns were Romi Lynne Acosta, Chris Amodo, Mark Aquino, Kristina Bautista, Maria Lourdes Del Rosario, Rod Daus-Magbual, Anne-Rose Duenas, Maurus Dumalaog, Jesus Perez Gonzales, Jeffrey Lapitan, Matthew Lew, Richard Likong, Barbara Linda Palaby-Gonzales, Pin@y Educational Partnerships teachers, Nikki Placido, Jerome Reyes, Tony Robles, Aldrich Sabac, Ray San Diego, Mahalaya Tintiangco-Cubales, and students in David Palumbo-Liu's class at Stanford University—Amy Dao, Tina Duong, Julian Jaravata, Healy Ko, Brianna Pang, Kristina Peralta, Krystie Villamayor, Kimberly Vu, and Jill Yuzuriha.

The committee wishes to give special thanks to the many local archivists and archives, scholars, the boards and staffs of community organizations, and history advocates for their assistance in the production of this book, including Drs. Fred and Dorothy Cordova, Filipino American National Historical Society, National Office; Al Acena, professor emeritus at College of San Mateo; Fred Basconcillo, former president of the Ironworkers Union; Dalisay Balunsat, Filipino American Center at the San Francisco Public Library; Kristina Bautista and the Filipino Community, Inc., of San Francisco; Alex S. Fabros, Ph.C., History, UC Santa Barbara; Amelia Fields and the Fields/Ricaforte family, Gran Oriente Archives; the Filipino Community Center; Christina Moretta, San Francisco History Center; Isaac Obenzinger and the Manilatown Heritage Foundation; Catherine Powell, Labor Archives and Research Center, San Francisco State University; Mitchell Yangson, Filipino American Center at the San Francisco Public Library; visual anthropologist and photography wizard Malcolm Collier, the Asian American Studies Department, and the College of Ethnic Studies, San Francisco State University.

Three San Francisco Bay Area organizations collaborated on this project: the Pin@y Educational Partnerships, the Filipino American National Historical Society, and the Manilatown Heritage Foundation. All proceeds will benefit their respective educational programs. Serving on the editorial committee were project manager Evelyn Luluquisen, Eduardo Datangel, Emil de Guzman, Daniel Phil Gonzales, Estella Habal, Dawn Bohulano Mabalon, Oscar Florentino Penaranda, Roy Recio, Tony Remington, Allyson Tintiangco-Cubales, Dennis Ubungen, Mitchell Yangson, Carlos Zialcita.

INTRODUCTION

This photographic journal is a history in images of and by Filipinos in San Francisco. Since the late 19th century, San Francisco has been a key gateway for Filipino passage into and throughout the greater U.S.. Filipinos have played a vital role in the development of the city and, in turn, the San Francisco experience has shaped the unique character of Filipino American society throughout the greater Bay Area, California, and the nation.

The range of activities of the individuals, families, and organizations chronicled here show the scope of diversity that existed amidst the Pinoy "bachelor" community—typically depicted in one-dimensional terms—that thrived in the city between World Wars. Children were raised in large, extended families, leaders established organizations with economic and political power, artists flourished, and students and workers joined in social movements. The images tell their tales—stories of a resilient community thriving in this extraordinary place despite often-difficult conditions. Here in, cherished heirlooms, is evidence of our development that confirms some perceptions and beliefs and contradicts others about Filipinos in America.

In 1898, two years after a rigged trial, conviction for sedition and treason, and the execution of Philippines national hero Jose Rizal by firing squad, independence-minded Filipino nationalists succeeded in their revolution against Spain only to be frustrated by U.S. intervention. Via the Treaty of Paris in 1898, Spain ceded the Philippine Islands (P.I.) to the U.S. by purchase. The U.S. then commenced a bloody war against "insurgents" continuing their struggle for independence. Soldiers assembled at the Presidio of San Francisco were deployed to the war from Fort Mason.More than one million Filipinos died from a gruesome combination of war-born disease and pestilence, U.S. military massacres of non-combatant civilians, and military combat. Pres. Theodore Roosevelt proclaimed an American victory in 1902—in reality, the war continued for a decade further.

The "Benevolent Assimilation" policy, announced by the succeeding president, William McKinley, instituted the first public education system in Philippine history and a political structure designed for U.S. social and economic control of the islands and military advantage in Asia. Admiral Dewey's victory over the Spanish fleet and the purported pacification of the Philippines were celebrated by cheering throngs at the 1903 dedication of a monument that still stands in the city's Union Square.

Anti-Asian laws that barred immigration by all "Orientals" did not apply to Filipinos because of the colonial status of the P.I. as a U.S. "territorial protectorate." Early 20th century arrivals from the P.I. included members of the mestizo (mixed-race) aristocracy seeking mercantile opportunities, their immediate families and support staff, and merchant mariners. The latter were participants in the four-centuries-long tradition of Filipinos working in the global shipping trade. First to arrive as a recognizable cohort were government-sponsored scholars known as pensionados (men) or pensionadas (women). Upon graduation from elite private and public universities in the U.S., pensionados were to return to the P.I. and take-up academic and civic leadership roles to facilitate the Americanization of their homeland. Some brought Anglo American wives back with them.

The enduring strength of the colonial connection between Filipinos and the U.S. military is patent in the 90-year history of military bases in the Islands and five generations of Filipino and Filipino American service, most notably in the U.S. Navy, starting as early as 1898. Upon their discharge or retirement from active service, many veterans found well-paying civilian jobs in navy and private shipyards and in the merchant marine, the latter often making San Francisco their base between voyages.

Filipinos in the U.S. Army last stationed at the Presidio also settled in San Francisco. Both black and white veterans of the Spanish American and Philippine-American Wars brought their

Filipina "war brides" and established multigenerational, mixed-race families here. Filipinos in the U.S. Army last stationed at the Presidio also settled in San Francisco.

Starting in 1906, workers were recruited from Visayan and Ilokano provinces directly to the sugar and pineapple plantations of Hawai'i. Like the Chinese and Japanese who preceded them, the Filipino sakadas organized and took militant measures against the abuses of the Hawaiian Sugar Planters Association in an effort to improve inhumane working conditions. Strikers were "blackballed"—permanently banned from the plantations. Former sakadas left Hawaii for the mainland in the 1910s and 1920s.

More workers were brought to the fields of the West Coast, lured by recruiters' promises of jobs and enthused by stories, money orders, and photographs in letters to families "back home." The photographs included with the letters frequently showed extremely well-dressed men in, on, and around fine automobiles and in the company of attractive Anglo American and "Latin-looking" young women. For many new arrivals, San Francisco was a stopover on the way to work in the fields and in the fishing and cannery industries of Washington and Alaska. The Alaskeros and migrant farm laborers often returned to the city for leisure time, urban jobs, and their own small businesses in the off-season. Some of these later arrivals pursued education in local high schools and area colleges and universities such as City College of San Francisco and San Francisco Teacher's College (now San Francisco State University), the University of San Francisco, and the University of California at Berkeley. The Depression caused most to quit school and find full-time work. Many of those who completed degrees found that racism prevented them from securing employment commensurate with their education.

By the late 1910s and early 1920s, those Pinoys who preferred urban service jobs stayed in San Francisco, renting rooms on and around Kearny Street adjacent to Chinatown and multiroom apartments ("flats") in the South of Market—now called SOMA), sometimes referred to as Central City—close to jobs in downtown restaurants, hotels, upscale private social clubs, and large department stores. On Kearny, later named "Manilatown," bachelor Manongs lived in the numerous single-room-occupancy hotels (SROs) such as the International and the St. Paul. Filipino-owned small businesses—restaurants, barbershops, pool halls, and sundries-and-liquor stores—abounded. The working class, ethnically-mixed neighborhoods of SOMA and the Fillmore/Western Addition offered larger apartments fit for growing families.

The Gran Oriente Filipino (GOF) Masonic Lodge and the Caballeros de Dimas Alang (CDA) of San Francisco were founded in 1921, while the Legionarios del Trabajo was established in 1924. Although categorized as legally as Mongolians and colloquially as "Orientals," Filipinos were not subject to anti-Oriental exclusionary laws regarding property ownership. The GOF purchased property in South Park to house their temple and living quarters. The CDA acquired a building on Broadway, just north of the International Hotel. The Filipino Community, Inc., established in 1939, bought a building at 2970 California Street.

Racial covenants, however, barred most Filipinos, like all other racial minorities, from renting or purchasing homes in exclusively white neighborhoods. Access to employment, like living quarters, was defined by race. Prohibitive signs, like the infamous and oft-cited "Positively No Dogs or Filipinos Allowed," were plentiful. Continuing anti-Asian xenophobia and the Great Depression increased anti-Filipino sentiment and violence throughout the West. In 1934, Filipinos were reclassified from "wards" and "nationals" to "aliens" and barred from entry to the United States by the Tydings-McDuffie Act.

The recruitment and immigration pattern caused an extreme imbalance in the ratio of men to women among Filipinos, typically cited as 18-to-1 or higher. State anti-miscegenation laws prohibited marriage between white and non-whites, though Pinoys often dared to be in the company of white women in full public view. Children of mixed-race or mixed ethnicity constituted a substantial portion of second generation Filipinos born before World War II.

Despite all obstacles, Filipinos made San Francisco their home and created a unique Filipino American culture and community. They established hometown and regional associations and annually celebrated December 30, Rizal Day, with princess and queen contests and fiestas. Filipino

immigrants brought their abiding passion for the arts, particularly music and dance. At work, they were bellhops, laundry workers, valets, barbers, cooks, merchant mariners, and warehousemen, but in their private lives many first-generation immigrants were also highly talented musicians, writers, artists, and journalists. Their talents flavored and colored family gatherings and community celebrations with an intermingling of black, Latino, and Filipino cultural expression in the Fillmore, the Mission, and on Kearny Street. The unique Filipino, American, and San Franciscan music culture that resulted was passed down through several generations to today, with many second- and following generation Filipino Americans gaining national and international recognition in various styles of music.

In sports, Pinoys cheered their fellow Filipinos who excelled in boxing. Despite segregated public facilities and other racist prohibitions, the second-generation's Mangos Athletic Club, founded in 1939, and the girls' division, the Mangoettes, excelled in basketball, baseball, softball, and volleyball, competing against Filipino and non-Filipino teams in California. Several members of the Mangos won city, state, and regional titles for their schools, as well as their community-sponsored teams. Victoria Taylor Manalo Draves, a mestiza Filipina from the South of Market, overcame anti-Filipino prejudice with discipline and exceptional talent to win five United States diving championships between 1946 and 1948. In 1948, she claimed two Olympic gold medals, one in springboard, the other in platform diving—the first woman in modern Olympic history to win both events and two golds in the same Games. In 2005, a park was dedicated to her in her old neighborhood, the SOMA.

Pressured by the Filipino American community and their congressional allies at the start of World War II, Pres. Franklin Delano Roosevelt signed changes in the military draft law making Filipinos draft and volunteer eligible for service in all branches of the U.S. military in 1942. The First and Second Filipino Regiments, U.S. Army, were established in California in 1942 for duty in the Pacific. In 1943, Filipinos in the U.S. armed forces were granted the opportunity to become U.S. citizens. At the close of the war, the Filipino regiments were awarded combat honors and distinction for their heroic contributions to the liberation of their homeland. The War Brides Act (1945) allowed veterans to bring wives and children to the U.S. Independence was granted to the Philippines on July 4, 1946.

In the post–World War II period, Filipino American progressives openly criticized U.S. domestic and foreign policy. In 1944, the Gran Oriente Filipino newsletter forcefully stated: "Race prejudice is nothing but a desire to keep a people down, and misuses the term 'inferior' to justify unfairness and injustice. Race prejudice makes people ruthless. It invites violence; it is the opposite of good character."

The GI Bill brought all U.S. military veterans access to higher education, well-paying civil service jobs and low-interest home loans. Filipinos began to buy homes in the Richmond and Sunset districts on the west side, despite white-only racial covenants. Others moved from the SOMA southward into the Mission, Bernal Heights, Excelsior/Outer Mission, Crocker Amazon, and Visitacion Valley neighborhoods and Daly City (of course).

During the "Cold War" era of the1950s and 1960s, Filipinos engaged San Francisco/Bay Area politics with increased vigor. They established political clubs and became leaders in the local Democratic and Republican parties, though once-powerful Filipino labor unions were slowly recovering from the chilling effects of McCarthy Era persecutions. Youthful Filipino American idealists supported the strengthening tide toward social justice. As artists, writers, and musicians, they participated in the Beat scene of North Beach, the jazz scene in the Fillmore, and San Francisco rock-n-roll culture even as their community's conservatives promoted quiet assimilation and criticized the goals and methods of the Civil Rights movement.

The Immigration Reform Act of 1965 welcomed university-educated technicians and professionals: nurses, doctors, engineers, accountants, and teachers from nations formerly barred or subject to exceedingly low annual quotas. An expanding economy driven by democratizing effects of the GI Bill and the Civil Rights Act provided new immigrants a higher level of economic mobility that had been denied the pioneer generation. The maturing pre-World War II second generation

followed first-generation relatives and friends into civil service, unionized blue collar jobs, small-businesses, and the corporate world. San Francisco swelled with new arrivals, filling the city's neighborhoods and churches.

The Vietnam War divided the nation and the Filipino community, as well. Filipino military veterans generally tended to support the war, and many young Filipinos volunteered or were drafted to serve. Others joined the growing opposition to the war.

In the 1960s and early 1970s, Civil Rights Movement and labor leaders, such as Larry Itliong, Philip Vera Cruz, and Pete Velasco, inspired young Filipino activists in the Bay Area to join the San Francisco Auto Row protests against racial segregation and the national grape boycott. Filipinos were active in the Free Speech Movement at UC Berkeley and were leaders of the longest student-led strike in U.S. history at SF State College in 1968. The Pilipino American Collegiate Endeavor (PACE) at SFSC was a member of the Third World Liberation Front and leader in the formation and implementation of the School of Ethnic Studies at SF State, the first in the nation.

The elderly Manongs and tenants of the International Hotel (I-Hotel) began their anti-eviction resistance in 1968. They were soon joined by students from SF State, UC Berkeley, and City College of San Francisco; many were veterans of the SF State and UC Berkeley strikes. The "I-Hotel Struggle" became an iconic issue in the city and a national focal point for the defense of working class communities and affordable housing against the destructive forces of "redevelopment" projects. It nourished the flowering of Asian American literature, art, music, and dance propagated by the Kearny Street Workshop, the Asian American Theater Workshop, and similar Bay Area organizations and institutions. Despite organized resistance via political and legal action and news media, on August 4, 1977, I-Hotel tenants and their supporters were violently evicted. Staunch I-Hotel advocates, however, successfully persisted in their cause for three decades.

The 1972 declaration of martial law in the Philippines by Pres. Ferdinand Marcos deeply divided the local community. The anti-Marcos movement had many strong adherents in the San Francisco Bay Area. Organizations such as the Movement for a Free Philippines; Katipunan ng mga Demokratikong Pilipino (KDP) or Union of Democratic Filipinos; the Anti-Martial Law Coalition; Friends of the Filipino People; and the San Francisco-based *Philippine News*. Spurred by the assassination of Benigno Aquino in 1983, the anti-Marcos opposition organized even more broadly in San Francisco, enthusiastically working to oust Ferdinand Marcos, who was exiled to the U.S. in 1986.

Political activism has continued through the 1980s to the present day, as Filipinos persistently advocate for civil rights, low-income housing, fair wages, better working conditions, equal access to quality public education, and full equity for Filipino veteranos. San Francisco's Filipino Americans are activists, teachers, counselors, engineers, architects, medical professionals, advocates for low income housing, writers and editors for major news outlets, on-camera television talent, producers and directors of films and videos, playwrights, actors, comedians, and more.

On August 26, 2005, an excited crowd of 700 gathered at the former site of the I-Hotel to cut the ceremonial ribbon at the official opening of the new International Hotel Senior Housing building. After 28 years of struggle, a 15-story building with 104 studio and one-bedroom apartments for low-income seniors rose up on Kearny Street. On the ground floor is the International Hotel Manilatown Center, sponsored by the Manilatown Heritage Foundation. A place to pay tribute to those evicted from the original I-Hotel in 1977 and to all the early Filipino immigrants, the center functions as a showcase for today's artists, poets, and musicians.

The bonds of identity and community among the generations of Filipino Americans are strengthened by the work of the many nonprofit cultural, religious, and social organizations and agencies serving San Francisco.

San Francisco's Filipinos have survived hardships and thrived. Today we are a dynamic and proud part of the city's colorful fabric. Our challenges—and triumphs—continue.

One

COMMUNITY BUILDING
HOME AND WORK

San Francisco was the gateway city for Filipinos coming to America. The earliest arrivals of the late 19th and early 20th centuries were merchant marines, aristocratic businesspeople with their families, wives, and children of buffalo soldiers, veterans of the Philippine-American War, *pensionadas/os*—Filipina/o students on scholarships at major U.S. universities, and a few intrepid travelers and their families. As early as the 1910s, they started families and established enduring community institutions in the Bay Area. By the 1930s, more than 50,000 had come, eager to pursue work, education, and adventure. Many would pass through San Francisco to the fields and fish canneries and to work in cities such as Stockton, Vallejo, Los Angeles, Portland, and Seattle.

Maximo Tormes (left), was born August 18, 1882, in Sibonga, Cebu. A merchant marine, Maximo arrived in 1904, witnessed the Great San Francisco Earthquake of 1906, and became a fireman in the U.S. Army Transport Service. Julia Haya arrived in February 1913 from Bago City, Bacolod, as caregiver for a wealthy family. Julia met and eventually wed Maximo in one of the first documented Filipino marriages in Oakland, California, in 1918. Daughter Caroline was born in San Francisco in 1920. (Both photographs, Ubungen family.)

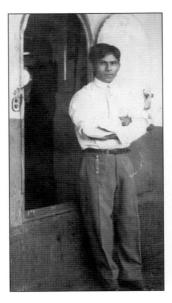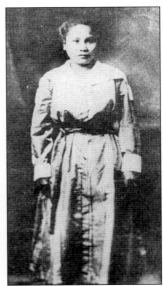

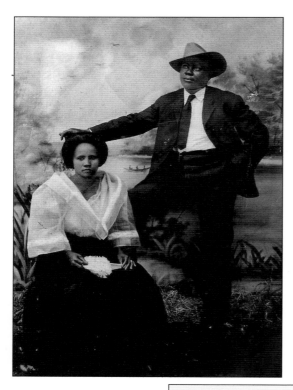

African American veterans of the 9th and 10th Cavalry Regiments, U.S. Army—the buffalo soldiers—were deployed to the Philippine American War (1899–1902) from Fort Mason of the San Francisco Presidio. Maria Osano (left) of Iloilo married cavalryman Henry Hudson Pitts (standing) of Atlanta, Georgia, in 1899. She arrived in San Francisco in 1915. They owned a home on Lyon Street in the Upper Fillmore/Western Addition neighborhood. Pitts worked for the U.S. Postal Service. (Clara Tronco/Marie Conde.)

Veteran Arthur Gubisch, born in Glogan, Germany, in 1873, immigrated to the United States, enlisted in the U.S. Army, and was sent to the Philippines during the Spanish-American War. Gubisch remained in the Philippines with his wife until his death in 1952. His children eventually migrated to San Francisco. In this photograph, from left to right, are George Bansuelo and Else Reyes Gubisch Bansuelo with their son, Arthur Gubisch, Alvin Reyes Gubisch, and an unidentified individual. (Vidda Chan.)

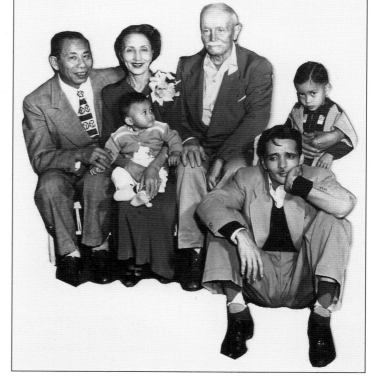

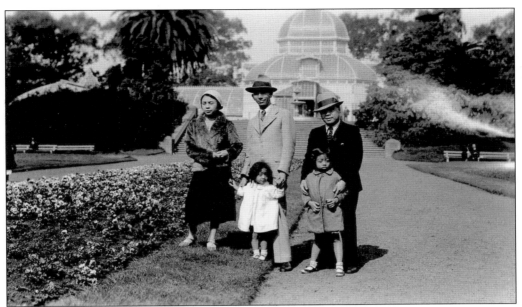

Frank Mancao recorded community life of the times in fine photographs. Here he stands (center) behind his daughter Betty. Mancao met and married Amanda Waten (left) while visiting his birthplace, Carcar, Cebu. Pictured on the right, the couple's daughter Annie stands with an unidentified friend. The Conservatory of Flowers in Golden Gate Park is the backdrop for this 1930s photograph. (FANHS, National.)

The Filipino Federation of America, founded by Hilario Moncado on December 27, 1925, was established in Los Angeles with lodges in San Francisco, Stockton, Seattle, and Hawaii. In this image taken in San Francisco on April 21, 1933, are, from left to right, (first row) Lapu Lapu Ramos; (second row) Hilario Moncado, president and founder, holding baby Octabo Ramos; (third row) Benito Ramos (left), supreme world council; Francisco Manigo (center), vice president; and Lauriana Ramos, women's supreme world council. (Perez family.)

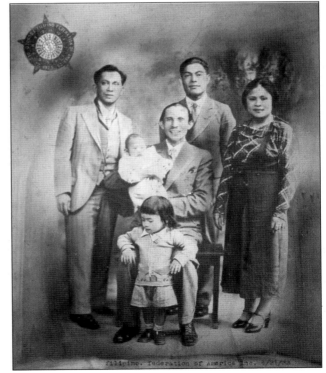

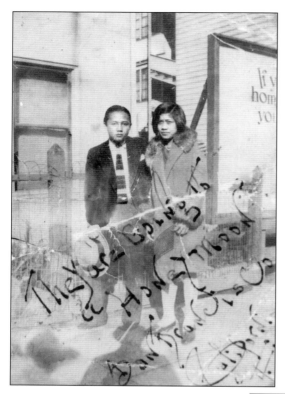

Marquita Escaldron and Remedios Robles met in San Francisco. Marquita came in 1926 as a nanny for her Auntie Tulusina's daughter. Marquita and Remedios married in San Francisco and together raised 10 children in the Fillmore district. (Robles family.)

Mrs. Mary Fontanilla—the former Mary Montayre from Kauai, Hawaii, whose father was Filipino and mother Austrian—posed for this c. 1936 photograph with her husband, Benny Fontanilla, from San Juan, La Union. Their daughter Rosalind Fontanilla was born in San Francisco in 1937. The family lived on Minna Street in the South of Market. (Rosalind Fontanilla.)

The fashionably attired Pablo Bautista strikes a languid pose in the 1930s. He sent this photograph to Cecilia Salvador to convince her to marry him. It worked. They settled first in the Fillmore district and later in the Haight-Ashbury. In his 40 years as a busboy at the St. Francis Hotel, Pablo reputedly never missed a day of work. The Bautistas were community leaders and officers of the Filipino Community of San Francisco. (Kristina Bautista.)

Abelardo Basconcillo (middle) takes a stance with two unidentified friends on the picturesque wooden bridge in the Japanese Tea Garden of Golden Gate Park. He was a successful restauranteur and businessman. (Basconcillo family.)

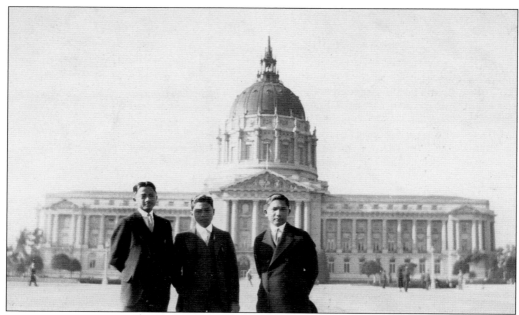

The *manong/manang* (respected elder man or woman) generation that arrived before World War II took great pride in their personal appearance. Artemio Espiritu Basconcillo (center) stands with two unidentified friends in front of San Francisco City Hall in the 1920s, all dressed in the very best and current style of the period. (Basconcillo family.)

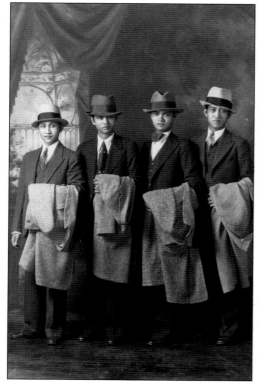

Gentlemen all, Lazaro Fabian (second from left) stands with three unidentified friends in sartorial splendor. Photographs like these—were staple accompaniment to letters and money orders sent regularly to the folks back home. They often inspired envy and emigration. (Larry Fabian.)

Timoteo N. Tercenio said, "It was an exciting and productive journey, all starting with a voyage on the merchant vessel, *SS President Jackson*, from Manila to the port of San Francisco in 1932." His daughter wrote, "motivated, industrious & charming, he did farm labor then bookkeeping, served in the U.S. Army—First Filipino Infantry, owned a business assembling auto parts while working for Simmons Company. Later he managed and maintained his investment properties." (Helen "Cricket" Tercenio-Holder.)

Kearny Street, from cross street Pine north to Pacific, was the hub of the growing community. From the 1910s to the early 1950s, Kearny was a primary destination for new arrivals in need of housing and information about jobs. Businesses such as the Luzon Restaurant, the New Luneta Café, Bataan Lunch, and smoke-shop-liquor-and-sundries stores catered to Filipino tastes and needs. Short- and long-term shelter was available at the International, the St. Paul, the Temple, and several other single-room occupancy hotels in the immediate area. Here, Fred Ubungen (left) and Caroline Tormes Ubungen enjoy coffee inside the Luzon Restaurant with three unidentified friends in the late 1930s. (Ubungen family.)

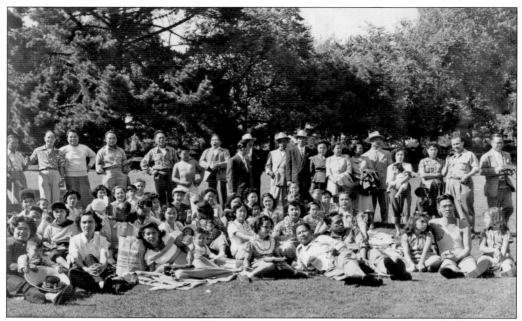

The fraternal order of the Caballeros de Dimas Alang (CDA), modeled after the Philippines original, was established in San Francisco on December 14, 1920. Dimas Alang was the nom de plume of national hero Dr. Jose Rizal. The Filipino fraternal orders were and are dedicated to the highest humanitarian philisophical values. Philippine nationalism, mutual aid, and assistance among its members and life-long responsibility to the welfare of the homeland. (Lisa Suguitan Melnick.)

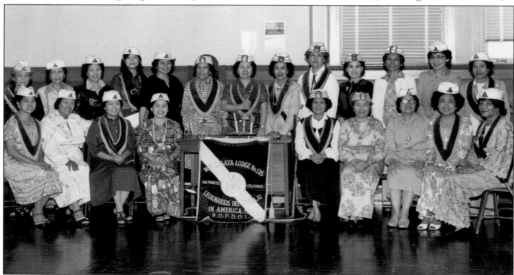

The Legionarios del Trabajo (LDT) fraternal order was modeled on the *Katipunan* of the nationalist, anticolonial revolution, the freemasonry, and a trade union concept. Founded in Manila in 1912, the LDT came to San Francisco in 1924. Though *Filipinas* (Filipino women) were outnumbered by men at least 18 to 1, they held organized social, cultural, and economic power via sororal women's auxiliaries of the fraternal orders. Pictured around 1940 are members of Worshipful Ligaya Lodge 135. (Abriam family.)

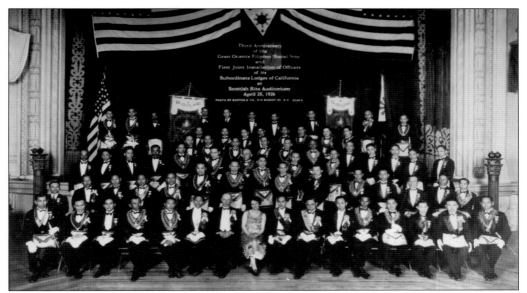

The American branch of the venerable Gran Oriente Filipino, a Masonic lodge in the Philippines, was established in San Francisco in 1921 by a group of former merchant marines. They gathered at the Scottish Rite Temple on April 25, 1926, for their first joint installation of officers. The lodge purchased property in South Park in the 1930s: the lodge's temple (on Jack London Street) and apartment houses (at 106 and 48 South Park). All are still owned and in use by the lodge. (Gran Oriente.)

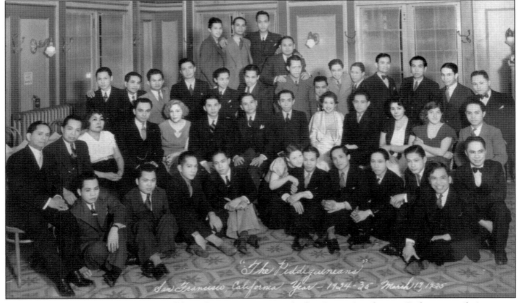

A group of townmates from Piddig, Ilocos Norte, includes Pete Ancheta, Calixto and Agustin Lucas, Vincente Suguitan, Angelo Albano, Ruperto Agcaioili, Felipe Fabian, Romuluz Hernaez, Paul Quevedo, Asisclo Pimentel, Abe Pascual, Camilo Aquino, Mariano Llanes, Mariano Aurelio, and Raymond Valentine. Not pictured are Antonio Addad, Paul Ildefonzo, and Lazaro Fabian. (Larry Fabian.)

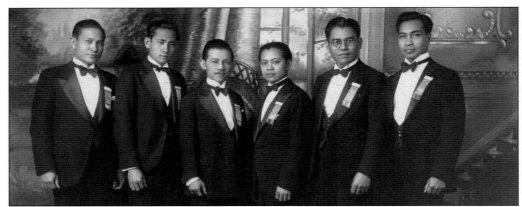

Officers of the San Francisco branch of the United Visayans, San Francisco, are pictured on March 30, 1930. From left to right are M. S. Cacafranca, auditor; F. Manago, secretary; J. L. Canseco, sergeant-at-arms; J. Taboada, president; C. T. Alfafara, vice president; and P. Perales, treasurer. This group, one of several, was a major contributor to the construction of the Philippine Pavilion, an exceedingly popular attraction at the International Exposition held at Treasure Island in 1939. (Lisa Suguitan Melnick.)

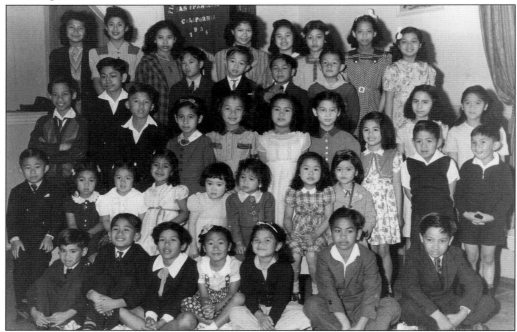

Members of the Filipino Children's Club, pictured from left to right, are (first row) Walter Yuponco, Sonny Paredes, Santos Beloy, Rohda Buted, Anata Alfafara, Jimmy Abad, and Alan Rillera; (second row) Benny Cachapero, unidentified, unidentified, Rose Cattiman, Betty Rillera, Rosita Vicente, Betty Pascual, and unidentified; (third row) Frank Beloy, Jimmy Caluen, Ralph Yngojo, Rolinda Vicente, Lourdes Suguitan, Nancy Augustin, Velma Yuponco, Agnes Yuponco, unidentified, Celestino Alfafara Jr., Lourdes Yuponco, and unidentified; (fourth row) Buddy Rillera, Rudy Calica, Herbert Rillera, and Art Suguitan; (fifth row) Lucrecia Suguitan, Betty Paredes, Feling Lucas, Corazon, Mata, Evelyn Yuponco, Annie Caluen, Virginia Quilala, and Ester Domingo. (Calica family.)

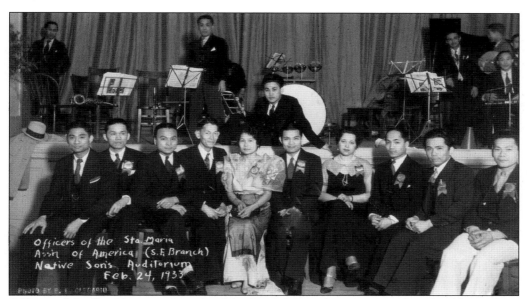

Officers of the San Francisco branch of the Santa Maria Association gathered at Native Sons Auditorium on February 24, 1933. Santa Maria is a town in Ilocos Sur. Hometown and Philippine provincial associations provided cultural activities, relief from homesickness and aid, and support in times of illness and death. Given the paucity of nuclear family structure of the "bachelor society" and the rarity of extended kin, these organizations were a vital structural element of the pre–World War II Filipino community. (Rosario Regino.)

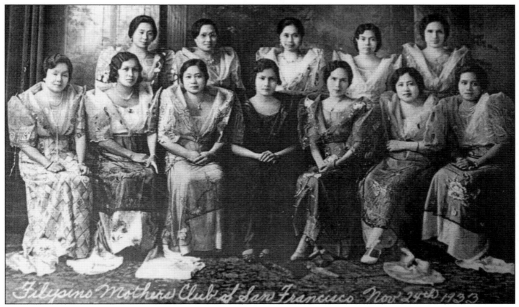

Members of the Filipino Mother's Club of San Francisco, pictured November 24, 1933, included a Mrs. Estoista, Mary Rillera, Germana Suguitan, Victoria Suguitan, Virginia Marcelo, Prospera Madamba, Anastasia Abenojar, a Mrs. Calloway, Magdalena Rillera, and Inocencia Agustin. In contradiction to the overly emphasized "bachelor" character of the inter–World War community, Filipinas nurtured children and managed families. (Urbiztondo family.)

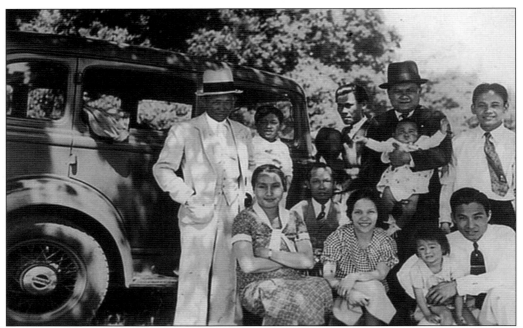

The Bautista clan (above), whose many members settled in San Francisco in the 1920s and 1930s, poses in front of their car. From left to right are (first row) Antonia Palafox, Juan Bautista, Consuelo Bautista, and Cornelio Antonio holding Adele Bautista; (second row) Johnny Dimalanta, Ernest Bautista, Moises Banez, and a Mr. Palafox holding his daughter Rose. (Urbiztondo family.)

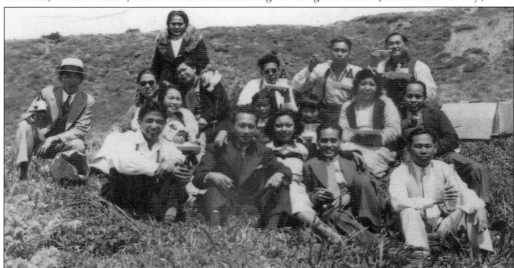

The Ubungen family, friends, and relatives enjoy a day at Ocean Beach in the late 1930s. From left to right are (first row) Fred Ubungen, George Ubungen, Caroline Tormes Ubungen, Alfonso Dacumas, and unidentified; (second row) far right, Benny Fontanilla—all others unidentified; (third row) unidentified, Ciriaco Bacani, unidentified woman, Nick Carrillo (wearing sunglasses), and two unidentified men; and (standing) Julia Haya Tormes. There was a diverse mix of Filipinos from different regions of the Philippines. As the Filipino community evolved, families grew. (Ubungen family.)

Rafael Yngojo Sr. poses with his
two children, Ralph and Dolores,
in 1930 on the stoop of their home
on Russian Hill. (Regina Eng.)

Children of the few families of the
pre–World War II era were especially
cherished. Their parents worked very hard
to keep them healthy, encouraged them
to do well academically, and supported
their education through college, if at all
possible. Rudy Calica (left) and Buddy
Ribella pose for a c. early 1930s photograph
in their best suits. (Urbiztondo family.)

In the 1930s and 1940s, the movie-driven Hollywood cowboy craze hit San Francisco. Entrepreneurs brought ponies, Western costumes, and their cameras to The City's streets for a day. Parents paid dearly for a chance to have their children in a photograph on a pony. Adele Bautista (left) and Emil Urbiztondo are the lucky children. (Urbiztondo family.)

For children who lived in San Francisco, the front porch was also a favorite place to pass the time. Here, Marquita Robles takes pause with her first set of five children. Pictured from left to right are (first row) Remy, Jeannie, and Alfred; (second row) Shirley, Marquita, and Hansel. (Left, Larry Fabian; below, Ralph and Jeannie Yngojo.)

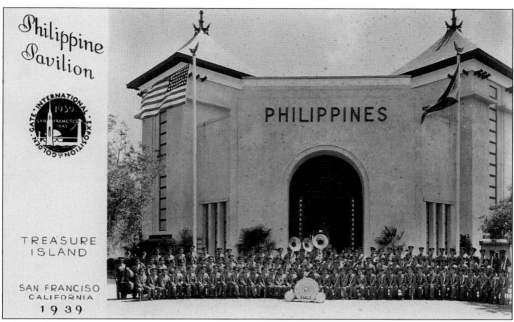

The Philippine Pavilion at the Golden Gate International Exposition on Treasure Island (above) in 1939 was a source of great community pride. The souvenir program states, "In the soft light streaming through *concha* (Capiz shell) windows, one begins to realize that he has suddenly been transported into a country different from his own—that everything about him exudes the languorous atmosphere of the tropics, from the highly polished floor and walls of the main lobby to the neatly dressed attendants and guides who show him around and explain the different features of the exhibit." (Ubungen family.)

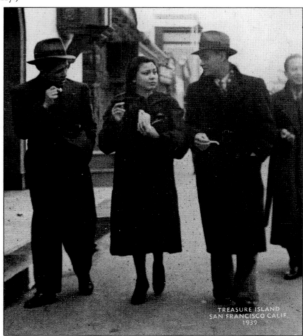

Fred Ubungen, left, and Caroline Tormes Ubungen, center, are pictured with an unidentified friend at the "T.I. Fair." (Ubungen family.)

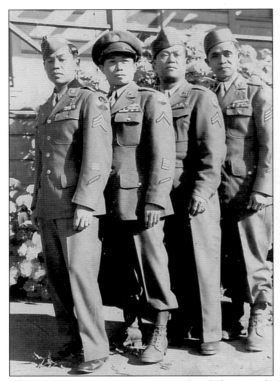

The U.S. Army veterans pictured at left around 1946 are wearing military insignia patches for the 1st and 2nd Filipino Infantry Regiments. From left to right are Sgt. Andres Lumicao Velasco, PFC Jovito Velasco Liban (U.S. Ground Forces Patch), Cpl. Basilio Dangilan (U.S. Army Air Corps Patch), and Sgt. Arcadio Cabanag. The two Filipino Infantry Regiments were formed in Salinas, California, and received numerous military decorations and honors for their role in the liberation of the Philippines from 1943 to 1945. Pictured at right, Nicholas Nava enlisted in the Philippines and served through the Vietnam era to retirement—a U.S. Navy "lifer." He and wife Lisa, a nurse, raised three daughters and a son on Treasure Island before being reassigned to the Seattle/Bremerton area. (Left, Larry Fabian; right, Palaby family.)

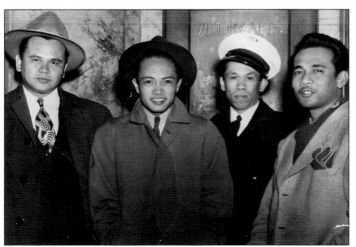

Pictured at the Victory Apartments, from the left to right are Paul Cato, unidentified, Matt Fontanilla, and unidentified. Paul and Matt both hailed from San Juan, La Union, Philippines. They arrived in San Francisco in the late 1920s. Matt lived to be 100 years old, having served in the U.S. Navy during World War II. He and his wife raised three daughters in the Excelsior/Outer Mission District. (Fontanilla family.)

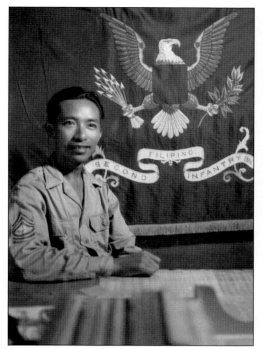
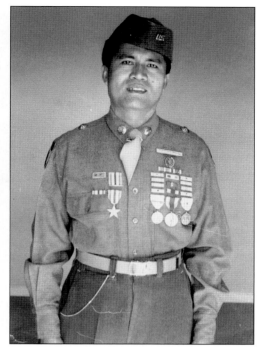

Sgt. Maj. Lazaro Fabian (left) joined the U.S. Army in 1943 and cofounded the 2nd Filipino Infantry Regiment Veterans Color Guard. Andrew A. "Anry" Jundis (right) served in the U.S. Army and was a Silver Star holder and a prisoner-of-war who survived the Bataan Death March and the Japanese concentration camp in Capas, Tarlac. (Larry Fabian, left; Vidda Chan, right.)

Cousins proudly posed with their World War II U.S. Army uncles at Jefferson Park at Laguna, Eddy, Gough, Turk Streets. In this c. 1942 photograph are (first row) Lourdes Elizarde, Betty Liban, Rudy Liban, Harold Liban, Larry Elizarde, Jack Liban, and Lorraine Elizarde; (second row) Perfecto Cabanag, U.S. Army; Perry Balunsat; unidentified, U.S. Army; Tony Cabanag; Domingo Logan, U.S. Army; Mike Lauagan, U.S. Army; and Domingo Calata, U.S. Army. (Liban family.)

The earliest Filipina/o communities were concentrated on Kearny Street, the Fillmore district, and the South of Market—also known in the 1960s as the Central City. After World War II, Filipinos began settling in greater numbers in the bustling South of Market. Here, friends and relatives welcome soldiers on leave. Pictured, in no particular order, are Mrs. Fe Dy, Captain Chavez, Si Ayag, Lieutenant Suatengco, Buong, Justo, Betty, Peter, and Nene. (M. C. Canlas.)

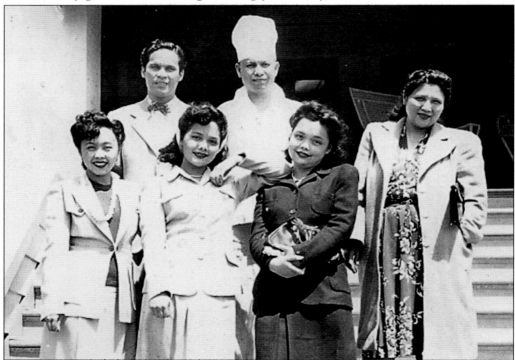

Hollywood actor Rudy Robles invited Pacita Todtod Bobadilla, Josephine and Juanita Begley, and Stella Sulit to lunch at a San Mateo country club where his brother (in chef's hat) worked. Pacita Todtod was a Filipina American Hollywood actress and singer and a very active leader in the Bay Area Filipino community. (Josephine Begley Alunan and Lily Alunan Dominguez.)

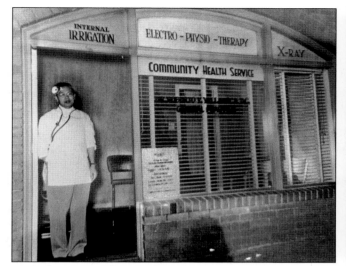
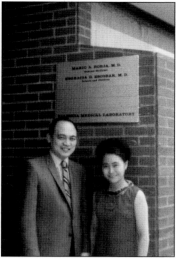

Dr. Roberto V. Vallangca (left photograph), licensed in 1946 to practice chiropractic medicine, studied art privately under Maynard Dixon, George Post, Diego Rivera, and Beniamino Bufano, and published *Pinoy: The First Wave: 1898–1941* in 1977. Drs. Mario Borja, internist, and Engracia Escobar, pediatrician, began their highly respected joint practice on Mission and Precita Streets in 1969. Dr. Borja was a leading member of the Filipino American Democratic Club in The City. (Bernadette Sy.)

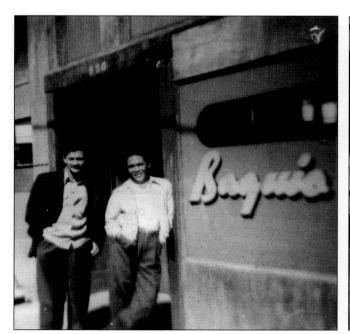

In the 1946 image on the left, Al Estrada and Max Ramos pose in front of Baguio Cafe, located at 930 Kearny Street. At right, Siblings Ralph (right) and Lourdes Yngojo are standing in front of their father's store in 1944. Raphael and his brother Jose Yngojo started their Yngojo Brothers grocery store in 1939 at Webster and Post Streets. (Left, Ramos family; right, Yngojo family.)

The Filipina/o American community in San Francisco mirrored national demographic trends as veterans returned with war brides, a second generation came of age, and families reunited after relaxed postwar naturalization and immigration laws allowed Filipinas/os to become citizens. Mary and her husband, Fred Motak, pose at Alamo Square soon after their 1946 marriage. (Motak family.)

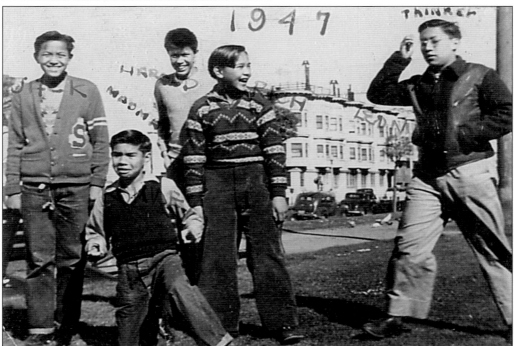

By the late 1940s and 1950s, a second generation was coming of age. In this 1947 photograph, young Filipino Americans enjoy time at Hamilton Park at Post and Geary Streets. From left to right are Jack Liban, unidentified, Richard Mazon, and Leon Mazon. (Liban family.)

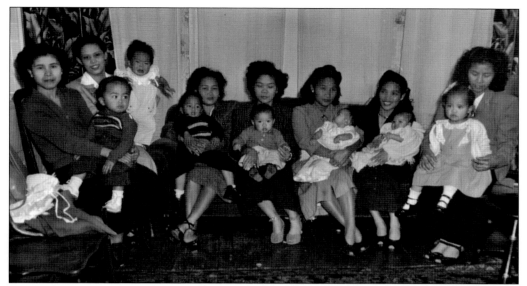

War brides, wives of Filipino veterans of the 1st and 2nd Filipino Infantries during World War II, socialize in one room while their husbands are in another. Seated in this 1950s photograph are (left to right) Irene Hipol with son Robert, Mrs. Evangalista with daughter Eleanor, Mrs. Calica with son Gary, Elena Pajara with son George (others unidentified). (Ellie Hipol Luis; photograph by Alex Hipol.)

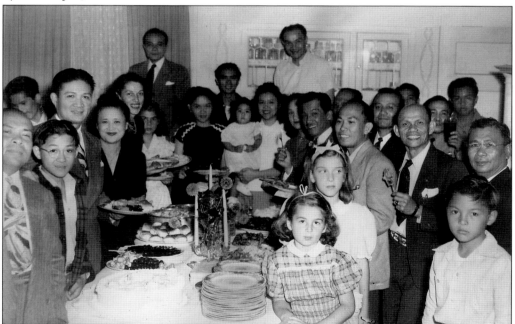

First birthdays are particularly important in the Filipino community. The first birthday of Mary Ann Poquez was celebrated on September 20, 1947. Among those in attendance were Joseph DeGuzman, Teodora DeGuzman, Emilio C. DeGuzman, Ramon Austria, and Rodolfo Reate, neighbors, friends, and family. The postwar prosperity of the Filipina/o community and their legendary hospitality are on full display here. (Maggie and Emil DeGuzman.)

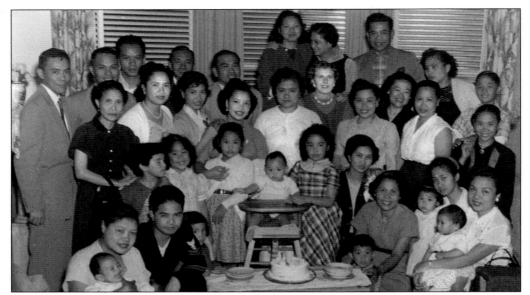

Celebrating Exequiel Kelly's (originally Exequiel Agngarayngay) son's first birthday, are (first row) Marina Bumagat holding Mel Bautista, Bert Acosta, Martha Cubi's daughter, and Bobby Salvador; (second row) Jane Cubi, Rosemarie Alvaro, unidentified, Rudy Kelly, Virginia Kelly Delacruz, Justina Panso, Cecilia Bautista, unidentified, Riling Soriano Balanon, Eufemia Ancheta, and Trina Salvador; (third row) Angela Mariano, Rose Alvaro, Patricia Ancheta Tseng, Ruth Kelly, Mila Manantang, Martha Cubi, Constance Kelly, Dominga, Catalina Jacinto, and Caridad Ramos; (fourth row) four unidentified, Steve Pasion, Marilou ?, Diana Ignacio, Exequiel Kelly, Marcy Salvador, and Douglas Ramos.

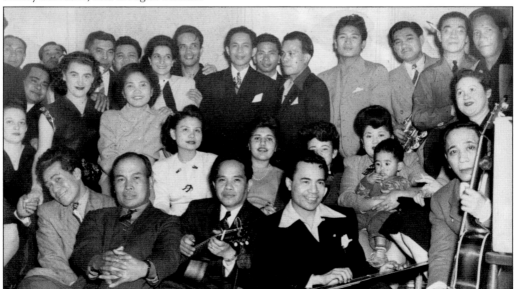

In many Filipino families, it is traditional is to have a gathering of family and friends on the first anniversary of a loved one's death. This photograph was taken during the gathering in memory of the late Albert Suguitan on February 23, 1947. Lorenzo Calica and Douglas Regino are identified. (Regino family.)

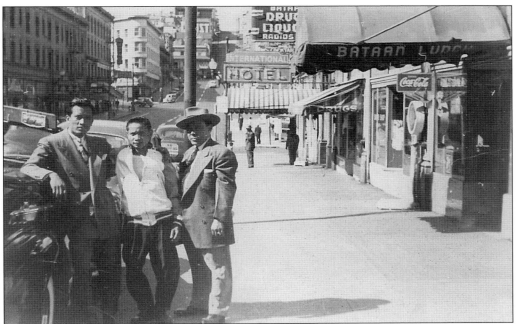

Kearny Street from Pine to Pacific Streets was known as Manilatown from the 1930s to the 1960s. It was the destination for new arrivals. Such businesses as the New Luneta Café, Mabuhay Gardens, Baguio Café, and Bataan Lunch catered to Filipinos. Hotels such as the Temple, St. Paul's, and the International Hotel were temporary and long-term homes. After World War II, the expansion of San Francisco's financial district and redevelopment dwindled the neighborhood down to several buildings on Kearny near Jackson Street. Photographs give evidence to this once thriving community. Above, a Mr. Lagrimas and his two unidentified friends show style on Kearny Street. (Alonzo family.)

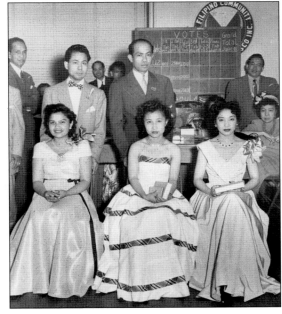

Until they lost popularity in the 1980s, queen contests had the potential to raise thousands of dollars but were also exploitative and repressive for Filipina girls, who were sometimes forced to participate by their parents. Candidates were usually the daughters of prominent community leaders. The 1948 queen contest raised almost $10,000 to pay off the mortgage of the Filipino Community Building at 2970 California Street. This photograph was taken during on May 28, 1949, at the Filipino Community building. (Lisa Suguitan Melnick; photograph by Manuel Nery.)

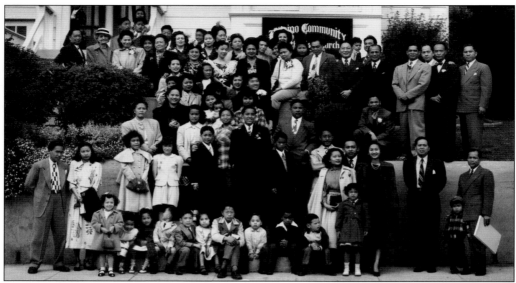

The Filipino Methodist Church celebrates Mother's Day on May 8, 1949. Thanks to Regina Eng and Harold Liban, many of the names are known. Identified in this photograph are (first row) Consuelo Liban, Peter Pabalan Jr., Rosadia Escueta, Rudy Liban, and Melvyn Escueta; (second row) Ner Cuyugan; (third row) Linda Bigornia, Natividad (Punkin) Pabalan, Frank Obien, Jack Liban, and Leon Mazon Jr.; (fourth row) Mrs. Natividad (Naty) Pinaroc, Pearl Pinaroc, Vincent Gomez Jr., Richard Mazon, and Rev. Florencio Marquez of Vallejo Methodist Church; (fifth row) Mrs. Adoracion (Doring) Binaley, Betty Liban, and Elinor Pinaroc; (sixth row) Grace Lapitan, Esther Pinaroc, Reyna Pabalan, Myrtle Lapitan, Audrey Pinaroc, and Betty Pinaroc; (seventh row) Mrs. Salud Cadelinia, a Mrs. Obien, a Mrs. Domingo, and Mrs. Vincent Gomez Sr.; (eighth row) Rev. Chun Lee (Chinese Methodist Church), Rev. Ermie Obien of Filipino Community Methodist Church, and Pete Pabalan; (ninth row) a Mr. Tenedero, Delia Cuyugan, a Mrs. Lee, Helen Marquez, Mrs. Natividad Pabalan, Maria Socorro Liban, and a Mrs. Rillera; (tenth row) MacArthur Pinaroc, Allen Rillera, and Herbert Rillera. (Abe Ignacio.)

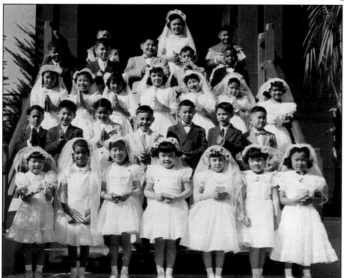

First Communion at Morning Star School stressed high academic standards and social justice and prepared students for leadership. Rev. Joseph Guetzloe officiated at all events accompanied by the Daughters of Mary and Joseph. Father Stoecke and the nuns of Morning Star and St. Michael's Schools protested the internment of the San Francisco Japanese community during World War II and regularly went to the camps to minister to the congregation. (Juanita Tamayo-Lott.)

Barbara Linda Palaby is pictured around 1953 on a kiddie ride at the old Playland at the Beach. She became a radiological technologist and raised two sons and a slow-to-mature husband in the city where they still reside. (Palaby family.)

Helen "Cricket" Tercenio-Holder was a dancer from infancy and became a legend at the hippest soul crowd dances and clubs in the 1960s. She and her sister Bernadette attended St. Anne's School. St. Anne's Church is in the background. "Cricket" was an outstanding cheerleader at Lincoln High. Barbara Linda Palaby (above) transferred from Lowell High to Lincoln, where she met and befriended Cricket, who went on to become a nurse and raised two daughters. (Helen Tercenio-Holder.).

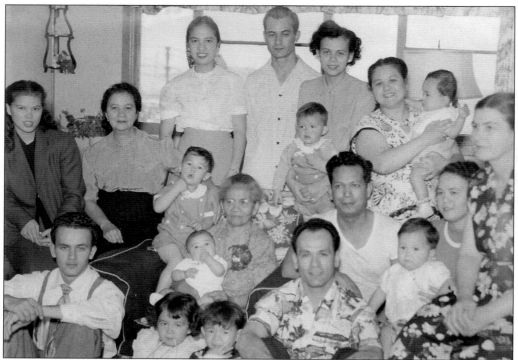

This group in the early 1950s includes (first row) Augustine Cook, Joan Cousart, and unidentified; (second row) Jimmy Jaboneta, Matea Cook holding Douglas Cook, Steve Navarro, Atilana (Cook) Calloway holding George Cousart, and unidentified; (third row) Joanne Cook (Mrs. Augustine), Juanita (Calloway) Gutierrez, Felly (Calloway) Cook, Esperanza (Cook) Jaboneta holding Raymond Jaboneta, and Federica (Cook) Navarro holding Edward Navarro. (Frank Cook.)

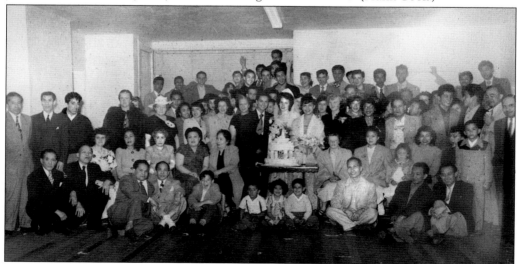

Among those attending the *c.* 1950 wedding of Salvador Jr. and Juanita Sorro at Filipino Community of San Francisco Hall, 2970 California Street, are Mr. and Mrs. Sorro (second and third from left), Bill Sorro (third from left in front row), and a Mrs. Robles (second row, fourth from left). (Sorro family.)

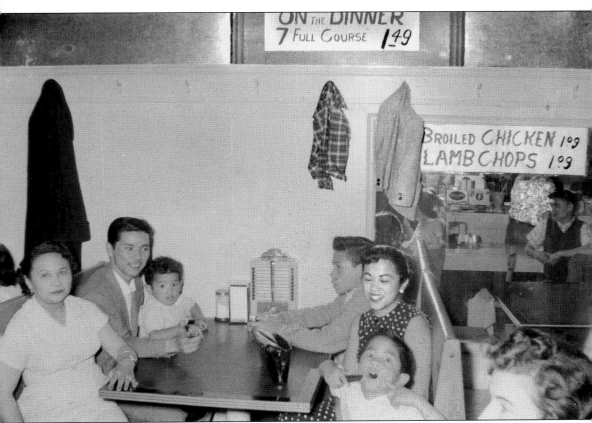

The San Diego family poses for a picture at the restaurant they owned in the Castro in the 1950s. (Ray San Diego.)

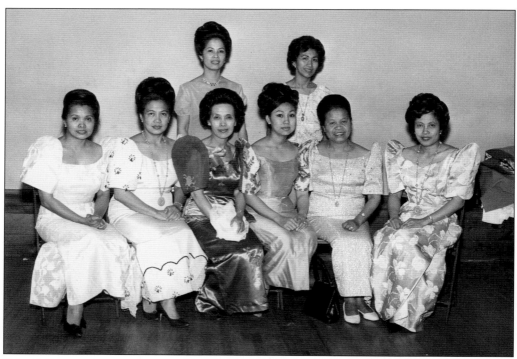

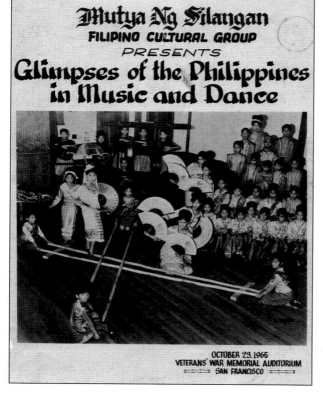

Mutya Ng Silangan
FILIPINO CULTURAL GROUP
PRESENTS
Glimpses of the Philippines in Music and Dance

OCTOBER 23, 1965
VETERANS' WAR MEMORIAL AUDITORIUM
SAN FRANCISCO

The Pearl of the Orient, formed in November 1950 under the leadership of Mrs. Alfonso M. Avecillia, the adult program director at the YMCA, sponsored projects including fundraising for Filipino residents of the International Hotel in San Francisco and Delano farm workers, visiting the sick, establishing a scholarship program, a Philippine cultural program lead by Helen Marte, and a cotillion for young women. Above are the officers of the Pearl of the Orient club, at the YWCA in 1962. They are, from left to right, Polly Arzaga, Gloria Abriam, Salud Cadelinia, Helen Marte, Lee Sandoval, Rose Florendo, and Mary Acdan. At left is the souvenir program cover for their cultural program: "Mutya Ng Silangan Filipino Cultural Group presents Glimpses of the Philippines in Music and Dance. October 23, 1965, at Veterans' War Memorial Auditorium, San Francisco." (Abriam family.)

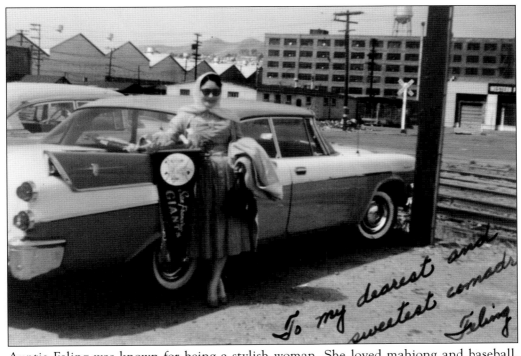

Auntie Feling was known for being a stylish woman. She loved mahjong and baseball. (Henry Collado.)

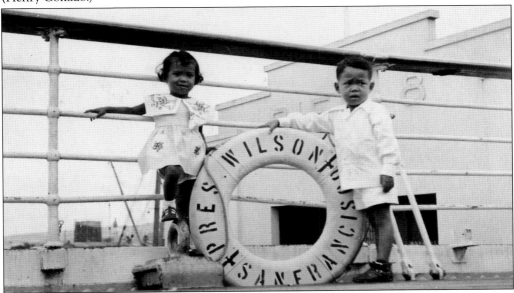

Siblings Christine Bohulano and Delfin Bohulano Jr. are aboard the *President Wilson* in August 1951, en route to San Francisco with their mother, Concepcion, to be reunited with their father, Delfin, who had left in advance to prepare a home in Vallejo. Deflin Bohulano was a 1st Filipino Infantry Regiment veteran. They settled in Stockton but often visited their uncle Segundo Omega at the International Hotel. Christine's daughter, Dawn Bohulano Mabalon, is a professor of history at San Francisco State University. (Dawn Bohulano Mabalon.)

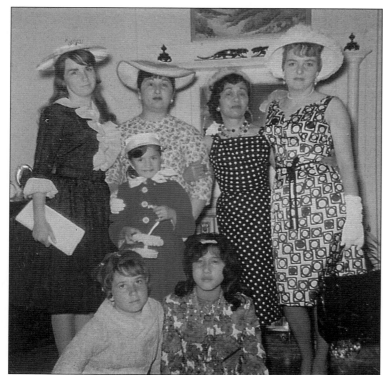

Filipinas in San Francisco were widely known for their style. Here, Robles women and friends sport spring hats and beautiful dresses. They are, from left to right, (first row) Linda and Drucilla; (second row) unidentified, Jeannie, Marquita, Betty. (Robles family.)

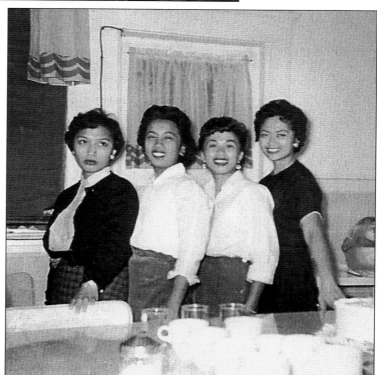

Stylish for all occasions, from left to right, Connie Adlao, Gloria Magpiong, Sash (Chefela) Oyao, and Rosita Adlao said they were "Four lovely beauties when cares of the world centered on us!" (Likong family.)

In this photograph taken in 1953 in their grandparent's backyard are, from left to right, Jack (16), Joe (18), Marlene (12), and Roger (14). All attended Morning Star Catholic School in the Fillmore district. Joe graduated from eighth grade in 1948 as class valedictorian. (Joe Julian.)

Filipino households often include extended families and several generations. Families open their homes to new arrivals, children whose parents are working, and those whose military fathers are stationed overseas. This photograph was taken at Dublin and Russia Streets in the Excelsior district in 1955. Ildefonzo girls Fely, Wely, Kathy, and Linda with their first cousin, Larry Fabian, along with their next-door neighbor were outside playing on a windy day. (Larry Fabian.)

41

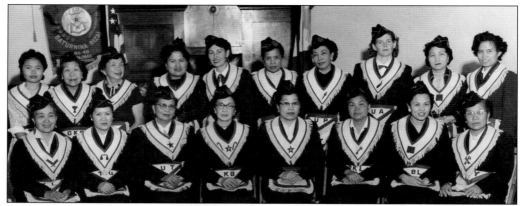

In 1952 there were seven women's lodges in the Caballeros Dimas Alang—Maria Clara in Stockton, Saturnina Rizal in Salinas, Tangdang Sora in Los Angeles, Gregoria de Jesus in Vallejo, Dona Aurora Quezon in Watsonville, Josefa Escoda in Mountain View, and Leonor Rivera in San Francisco. Above, the San Francisco chapter meets with the Salinas lodge. Below, the Caballeros Dimas Alang celebrates its 34th anniversary with a four-tiered cake. Five officers including Celestino Alfafara. (Both, Lisa Melnick.)

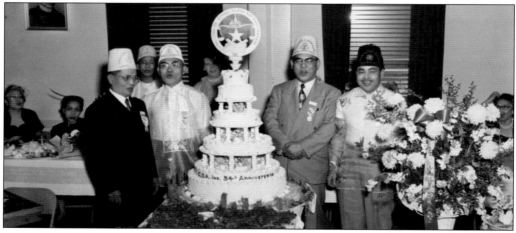

Fillmore neighbors and friends gather at Greta and Harold's apartment. They include, from left to right, Punkin Pabalan, Lolita Elizarde, Consuelo Liban, Joannie Pena, two unidentified, Fern Gonzalo, and Grace Lapitan. (Liban family.)

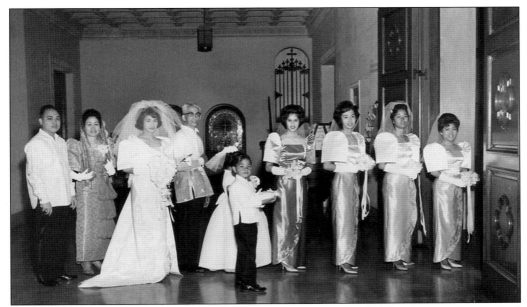

Family gatherings such as weddings bring together the large extended families spanning several generations born in the United States and recent arrivals from the Philippines. Posing in their glamorous Filipiniana attire, a bride, her parents, ring bearer, and bridesmaids pause before marching down the aisle at St. Anne's in the Sunset in 1963. All are unidentified. (Shirley Dimapilis, the San Francisco History Center, San Francisco Public Library.)

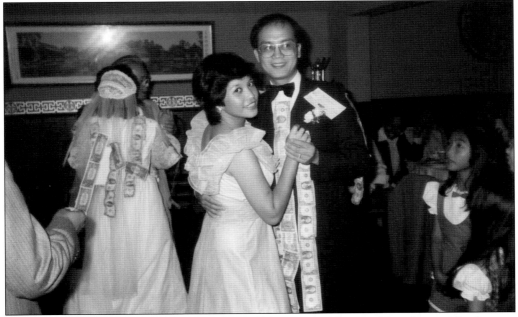

Parents and elders believe that newlyweds should have a good financial foundation. The "money dance" always takes place at Filipino weddings. All pull out their wallets when they start passing out the pins. Two separate lines are formed (for men/boys and women/girls) to take turns pinning dollar bills on the bride and groom for a brief dance. (De la Cruz family.)

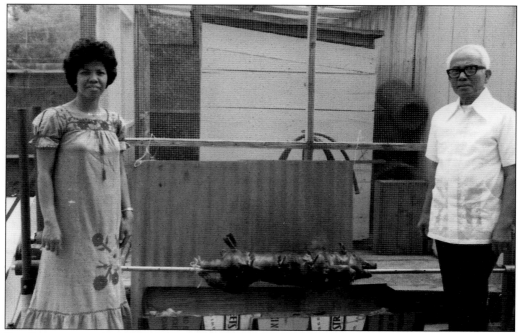

San Francisco residents did not let their urban environment hinder their enjoyment of celebrations and foods in rural settings. John Ricaforte and his daughter Amelia Ricaforte Fields roast an "urban lechon" in a split oil barrel in their backyard in the Bayview Hunters Point neighborhood in the 1960s. (Amelia Fields.)

Snow unexpectedly blanketed San Francisco on Saturday morning, January 20, 1962. Rod McLeod shared, "This was the first snow my family had seen in the city. We greeted the rare event with spontaneous joy and exuberance. We made a snowman, had snowball fights and after our clothes became stiff from the cold snow, my mother made hot chocolate and her special bibingka for us. The snow melted by mid-afternoon, but we will never forget that rare day when we played in the snow in our backyard. [From left to right are] Evelyn McLeod; Tootsie Montero; my mother, Julita [McLeod]; my little sister, Bonnie [McLeod]; Ernie Inacay, me [Rod McLeod], and Roddy Candelaria." (Rod McLeod.)

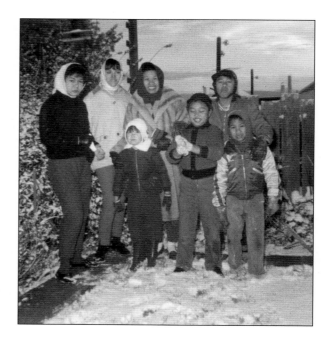

Flora Del Rosario, holding her daughter Lora Lee, operated a dry cleaner and laundry with her husband, Frisco Del Rosario. The business was located at 1714 Franklin Street from 1959 to 1962. (Lora Lee Del Rosario.)

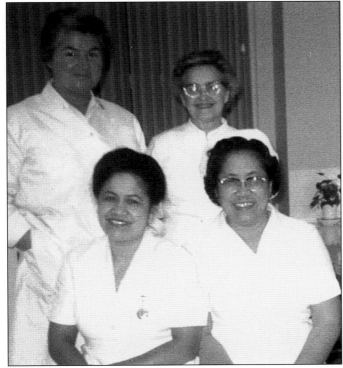

Florencia Tercenio (first row, left) worked at Notre Dame Hospital on Van Ness and Broadway around 1961–1962 and transferred to its parent company, St. Mary's Hospital on Stanyan Street, where she remained until retirement in 1983. (Helen Tercenio-Holder.)

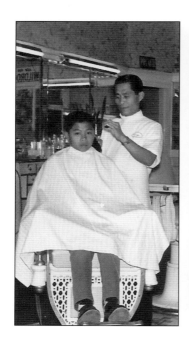
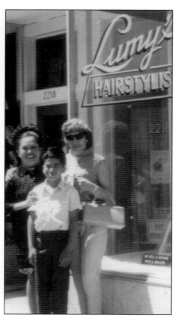

At left, Lino A. Jubilado with his eldest son, Lino Jr., owned the Latin American Barber Shop located at Seventh and Mission Streets. He married Serafina Flores while stationed in the Philippines during World War II. At right, Illuminada "Lumy" Competente Luis, a war bride to Monico B. Luis Sr., stands with a Mrs. Juanillo and her son. Lumy studied at Marineloís Beauty School and owned salons in the Mission and Sunset districts. (Far left, Priscilla Jubilado; left, Ben Luis.)

This is Standard Oil Shipping's Stewards Department Reunion in 1978. As cooks, kitchen help, and cabin boys, or personal servants, to officers, many highly educated Filipinos with degrees—some World War II veterans—knew these were the only types of jobs available to them. In this photograph are, (first row) J. R. Dacanay, D. R. Magno, V. T. Fontanoza, M. A. Mayo, M. M. Galon, V. M. Pozon, C. M. Cuyos, D. M. Morales, and S. C. Pareja; (second row) B. K. Recarse, T. A. Fox, L. R. Mijares, J. F. Oquendo, D. R. Magalit, J. V. Valgoma, P. D. Laput, B. M. Capuyan, C. Lasprillas, A. Alagdon, O. A. Roldan, A. G. Sabado, and A. J. Flores. (Benito Capuyan III.)

The Hunters Point Naval Shipyard (HPNS) offered opportunities for employment and social networking. Above, Atilana (Cook) Calloway was a clerk typist and library assistant from 1945 to 1970. She often sang at office social events, and at home she met many challenges as a working mother. Robert Jetalado Cousart was an account supply clerk from 1945 to 1967. In the Philippines, he was known as "Tiger Roberts," holding titles in boxing and wrestling, bantamweight division. He married Atilana's sister, Maura. Below is the Hunters Point Shipfitters Reunion Cream of the Crop around 1980. This close-knit, highly skilled group from San Francisco took pride in their work to keep ships safe. They are, from left to right, Eufronio "Eddie" Espina, Ray Chow, Harold Liban, Hanson Hong, and Chris Camilo. (Above, Dennis Calloway; below, Harold Liban.)

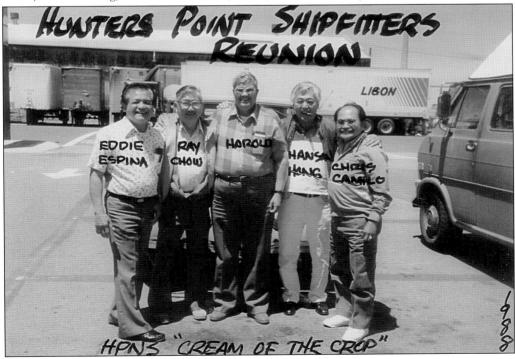

47

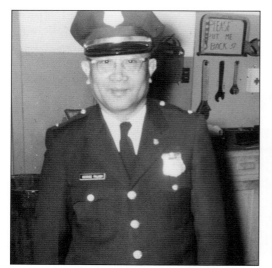 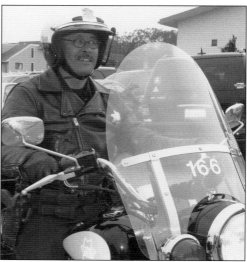

George S. Palaby (left) was a World War II 1st Filipino Regiment and Korean War veteran. He was a federal security officer on Alcatraz Island during the 1969 American Indian Movement (AIM) takeover of the island. Arthur Gabac (right), an SF State grad and three-decade veteran of the San Francisco Police Department, sits astride his motorcycle in 2010. (Left, B. L. Palaby; right, D. P. Gonzales.)

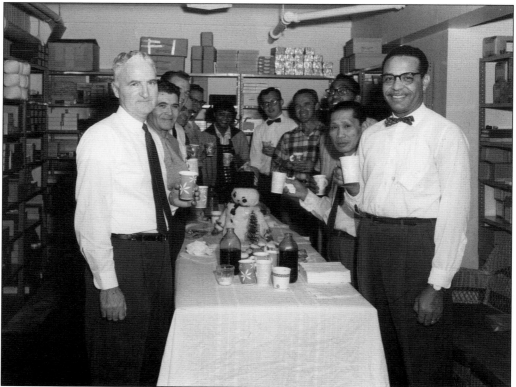

Mr. Abriam, second from right, celebrates the holidays in the office supply room with coworkers in the federal building. (Abriam family.)

Segundina San Juan was a staff research associate at the University of California, San Francisco (UCSF) medical center. The UCSF United Filipino group was an employee association which offered camaraderie and mutual support to Filipino employees at the university. (Laarni San Juan.)

Benjamin Joseph Calica (left) was born 1934 to parents from Naguilian, La Union. He attended Roosevelt Middle School and Polytechnic High School and became an engineer. The magician (right) wrote, "To my friend Tino, Just a little souvenir and remembrance with best wishes for success. From the Filipino Magician. The only Filipino member of the SF Giants Booster Club of Northern Calif. Sincerely, Wens L. Abello." (Left, Kelly Calica; right, Regino family.)

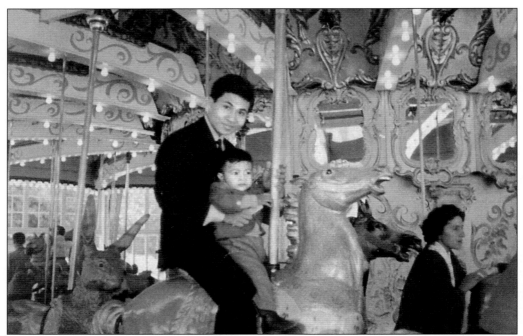

Golden Gate Park is the perfect setting for family leisure activities. Here a Mr. Castaneda spends a Sunday afternoon riding the carousel with his son. (Castaneda family.)

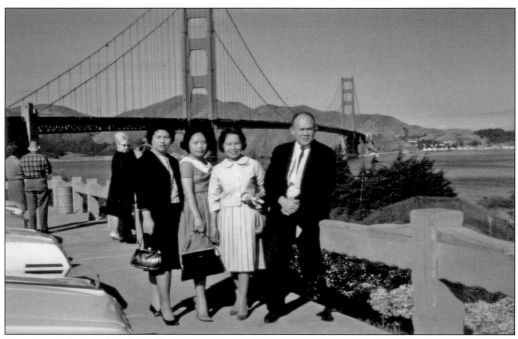

For many Filipino families, the iconic San Francisco photograph was of them with the Golden Gate Bridge. Posing in front of the bridge in this early 1960s image are Generosa Anolin, ? Anolin, Marcelina Capuyan, and Benito Capuyan Sr. (Capuyan family.)

The Filipino population in the South of Market surged after 1965. Here, the Pascua family and friends pose for a picture at 10th and Howard Streets outside of St. Joseph's Church and School. Family members include Carl Dominic Pascua, Ernest Cajulao, Donna Lacuesta Pascua, Sr. Cornelia Ramirez (principal at St. Joseph's School), unidentified, unidentified, Venus Cajulao, Carina Lacuesta, and other friends. (Donna Pascua.)

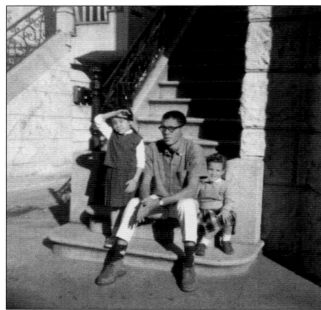

Leon Cathey sits with his daughters Lorraine (left) and Arlene Elizabeth on the steps of his home on Central Avenue in the Haight-Ashbury district. The maternal and paternal grandson of buffalo soldiers, he earned multiple degrees in the sciences in the United States and Europe. A marine biologist, Leon taught biology at Washington and Galileo High Schools and in the College of Ethnic Studies at San Francisco State. (Leon Cathey.)

The Geli sisters and their family were a North Beach neighborhood legend among their peers in the 1960s and early 1970s. To do a history of this dynamic and interesting clan would require at least one heavy volume. From left to right are Mignon, Josephine, friend Marilyn Eng, and Maria. (Mignon Geli.)

The Filipino Professionals and Businessmen's Association (FILPABA) of San Francisco scheduled regular meetings with elected officials to advocate for local Filipino business interests in the 1970s and 1980s. FILPABA took part in the 1974 Filipino American Friendship Day Parade with a float called Golden Gateway to Friendship. Shown here are Gerry Sy and his son, Tony. (Bernadette Sy.)

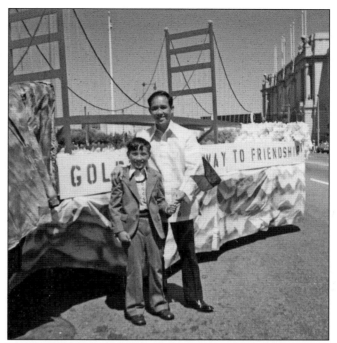

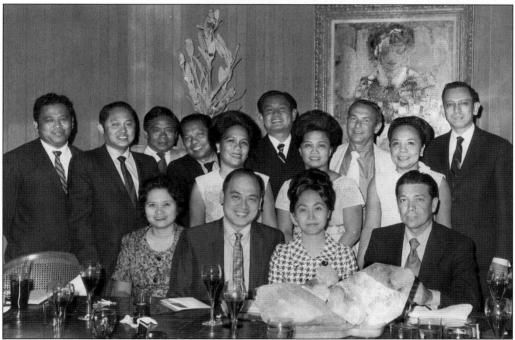

Filipina/o medical professionals, including nurses and doctors, settled in the San Francisco Bay Area where their services were highly regarded. In the 1970s, Filipina/o doctors gather for a social night out. They are, from left to right, (first row) Dr. Ebalo, Dr. Borja, Dr. Escobar, and Dr. Vargas; (second row) Dr. Badillo, Dr. Ortiz, Dr. Hilario, Dr. Candelaria, Dr. Cristobal, Dr. Malabed, Dr. Muriera, unidentified, Dr. Catajan, and Dr. Ver. (Bernadette Sy.)

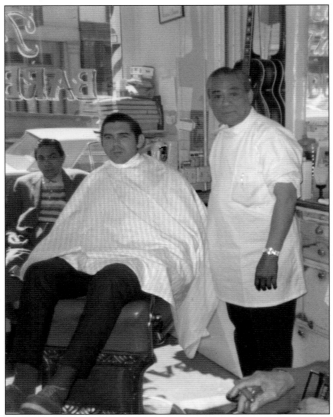

Faustino Regino came to San Francisco in 1929 and was later joined by three more brothers. Faustino "Tino" trained as a barber, worked as a utility man during World War II, and in 1969 was hired by the U.S. Immigration and Naturalization Service to work as an interpreter of Ilocano and Tagalog. Known as the Mayor of Kearny Street or the Mayor of Manilatown, Tino owned and operated a barbershop at 840 Kearny Street; it was a gathering place for elderly single Filipino men who exchanged news, shared stories, and played their musical instruments. Tino was always available to lend a few dollars to a sailor on shore leave or to visit a friend in the hospital. At left, Tino poses with an unidentified customer. Below, musicians are having a jam session in Tino's barbershop. (Right, Regino family; below, photograph by D. P. Gonzales.)

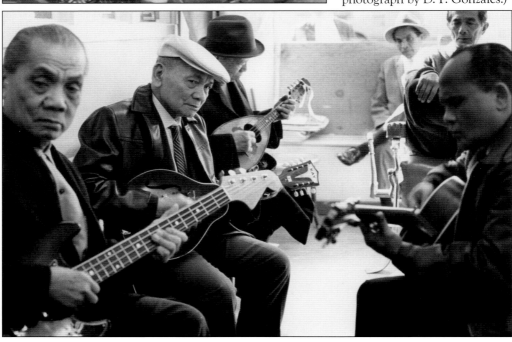

Manong-generation men often remained lifetime bachelors. The pattern of seasonal movement from work in the fields and canneries back to low-wage jobs in the cities during the off seasons was detrimental to long-term relationships and family life. Despite their "single" status, these men possessed a strong sense of community. Ever-dapper Benny Gallo (above left) and philosophical Felix Ayson (above right) were among the genuine gentlemen conversationalists who resided at the International Hotel. Below, Claudio Domingo (below, on the left), Anacleto Moniz (below, seated), and Luisa de la Cruz tended a garden in the second-floor light well of the I-Hotel. (Courtesy of the Manilatown Heritage Archive; photographs by Chris Huie.)

The Giles family represents three generations of an African American–Filipino union. Grandmother Giles (first row, right) operated a florist shop in the Excelsior district of San Francisco and was a central figure in Filipino community social and cultural activities. The Giles children were involved in the athletic and cultural activities of their generation. Among them were surfers and musicians—the latter playing professionally in San Francisco and Hawaii as the versatile Giles Brothers Band. (Larry "King" Giles.)

Beginning in the 1950s, old-timers and new immigrants began moving to the working-class Outer Mission and Excelsior districts. Here, the christening of the first son of the Capacillo family brought together parents, godparents, family, and friends at the Corpus Christi Church in the early 1980s. (Christine Capacillo.)

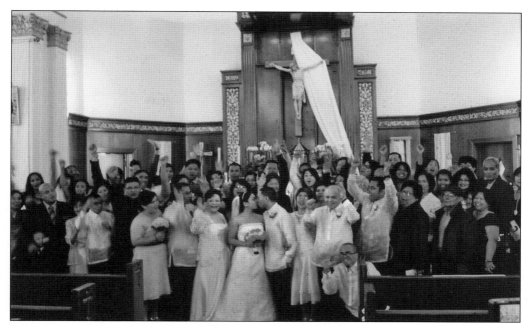

Yolanda Bomongcag Castaneda and Jhulsany Gallanosa Futol embrace as their families express excitement over their long-awaited marriage at St. Finn Barr Catholic Church. Parents Oscar and Thelma Castaneda and Lourdes and Albert Futol Sr. are elated. The photograph is dedicated to Albert Futol Sr., who fell ill and passed away shortly after the wedding. (Futol family.)

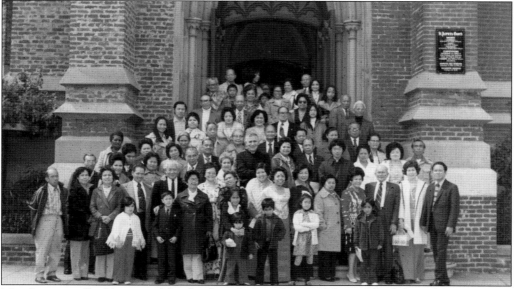

Mrs. Ascuncion Panlibuton and families from Antique Province, Panay Island, formed an association at Saint Patrick's Catholic Church on Mission Street. Father Daly, an Irish priest who once lived in Antique, spoke their Kinaraya dialect. Families who have continued to be active include Andres and Meniang Belarmino; members of the Pahilga, Calibjo, and Sampior families; Steve and Carmen Monteclaro, and Remy and Pacing Baloon. (Remy Jr. is a judge in Sacramento.) St. Patrick's is still home to a large Filipino community. (Annie Panlibutan Barnes.)

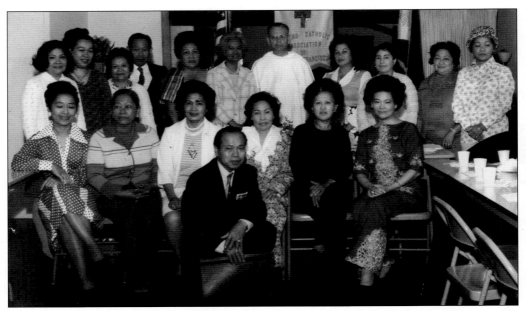

In 1974 the Filipino Catholic Association of San Francisco hosted the 12th annual convention for the Filipino Catholic Federation of America at the Jack Tar Hotel and Saint Dominic's Parish. Lead organizers were Ann Sabiniano, Gloria Abriam, Delia Reyes, Enrica Zabala, Darie Ann Reyes, Rose Vitin, Dick Gornot, Elvira Valencia, Patria Linato, and Nattie Bulatao. The theme was Year of Reconciliation—That We May Be One. (Abriam family.)

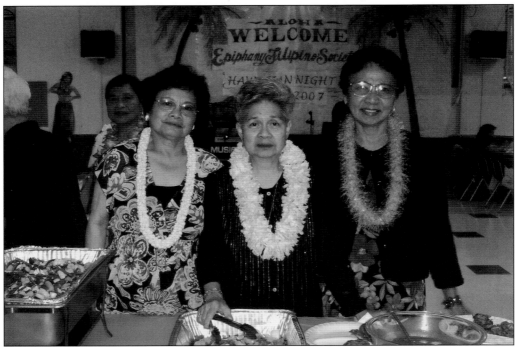

The Church of the Epiphany Filipino Society, here with Madelyn Bello and unidentified friends, celebrates its anniversary in 2007 with an aloha theme. (Madelyn Bello.)

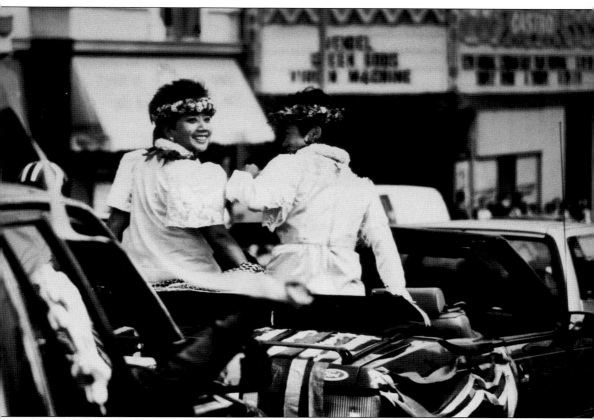

Trinity Ordona (left) and Desiree Thompson sit atop their "Bridal Car" as they jubilantly ride through San Francisco's main gay district, the Castro, following their wedding in Golden Gate Park on June 25, 1988. (Trinity Ordona; photograph by Julie Potratz.)

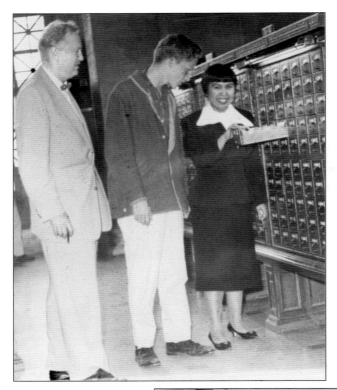

Dalisay "Dali" Bocobo Balunsat (right), a University of the Philippines graduate, established the Filipiniana section at the San Francisco Public Library and was the first director of its Filipino American collection. The other individuals in this image are unidentified. (Dali Bocobo Balunsat.)

Marilyn Manalo (left) and director Mitchell Yangson of the Filipino American Center of the San Francisco Public Library. The Center, which opened in 1996, collects and maintains material and sponsors programs and activities that document Filipino Americans and educate the general public about them. (Mitchell Yangson.)

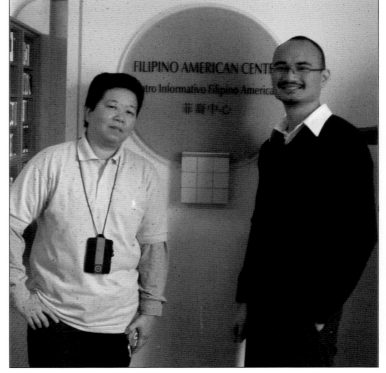

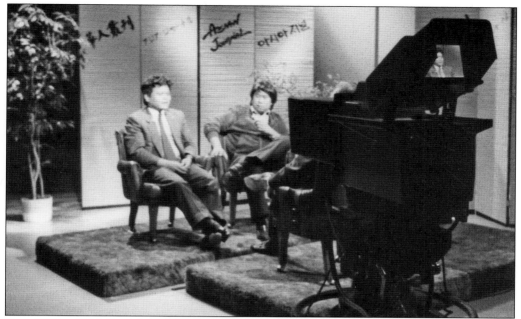

From 1987 to 1990, Ben Menor hosted the "Filipino-American Journal," a segment of *Asian Journal*, a public affairs program on KTSF, Channel 26. The program rotated Filipino, Chinese, Japanese, and Vietnamese American community affairs content. Emil Guillermo (left), a noted television and print journalist, shared his experiences as a Filipino in mainstream American media. Daniel Phil Gonzales, Asian American Studies professor at San Francisco State University, addressed issues regarding historical portrayals of Filipinos in American media. (D. P. Gonzales; photograph by Antonio de Castro.)

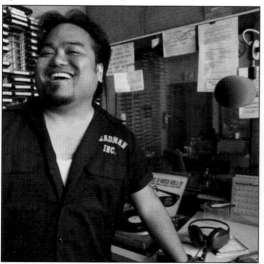

Ted Prado (left) has been a DJ for almost 25 years at KUSF, where he produces the *Jukebox* show. The *SF Weekly* voted him the Best Local Radio DJ. The *Filipino-American Report* aired on KMTP TV-32 in San Francisco. Its staff includes, Margaret Lacson-Ecarma (left), executive producer/anchor; Ez Ballesteros-Yap (center), associate producer/reporter/anchor; and Lorraine Mallare-Jimenez, reporter/anchor. (Left, Ted Prado; right, Pep Red Vasquez.)

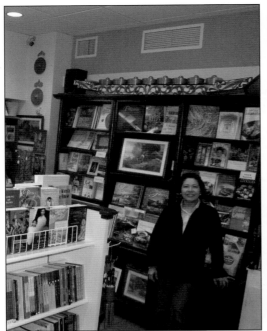

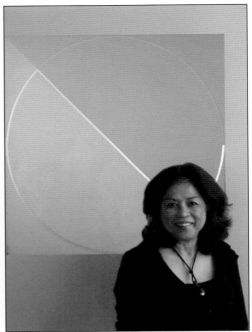

ARKIPELAGO, owned by Marie Romero (left), is a full-service, community-based specialty books and arts store that serves as an information resource center for Filipinos and those interested in learning about the Philippines and Filipino Americans. Julina Togonon (right) founded the Togonon Gallery in 1994. A curatorial focus for the gallery is showcasing Asian American artists, including Filipino American minimalist painter Leo Valledor. Julina served two terms as a board member for the San Francisco Art Dealers Association (SFADA) and is a member of the Art Table for professional women in the visual arts. (Left, Marie Romero; right, Julina Tagonon.)

In 2000, six staff members of the *San Francisco Chronicle* created Pinoy Pod, the first podcast channel at a major U.S. metropolitan newspaper geared to an ethnic community. The Pinoy Pod team included, from left to right, Cicero Estrella, metro reporter; Michelle De Vera, copy editor; unidentified; Leslie Guevara, city editor; Benny Evangelista, business reporter; and Benjamin Pimentel, business reporter. (Greg Macabenta.)

Two

THE ARTS

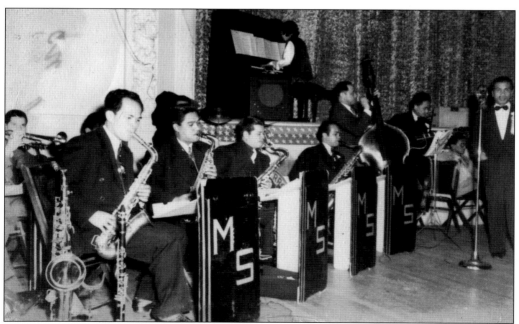

The Manila Swingsters was based in San Francisco and featured Lorenzo Calica (far left) and Nestor "Douglas" Regino (second from left) on saxophones. Calica worked as a janitor at the Saint Francis Hospital and played weekends with fellow musicians such as Henry Abenojar, Julian Castillo, Leo Estoista, Mel Estopare and Mauricio Regino. (Regino family.)

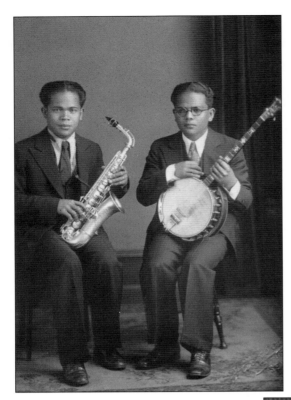

Saxophonist Lorenzo Calica (left) toured the United States with his band, The Manila Serenaders. He was a musician, composer, and family man. This photograph was taken with his banjo-playing brother Mauricio Calica on their arrival to San Francisco after gigs in Alaska and Washington State. (Calica-Zamora family.)

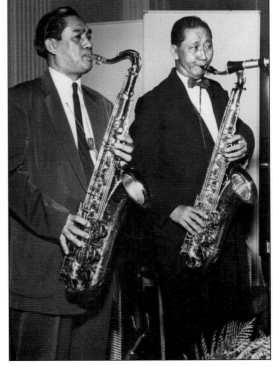

Nestor "Douglas" Regino (above right, on left) was a merchant seaman and later worked as a barber and restaurant pantry man. Douglas was best known as a musician and for leading the Gaylanders Orchestra. (Regino family.)

In the late 1950s and 1960s, Jo Canion (right) sang with The Preludes, a jazz vocal quartet that included her brother, the late pianist and singer Rudy Tenio. Her credits include Flip Nunez, George Duke, Smith Dobson, and Eddie Duran. Jo's daughters were the "Third Wave" group backed by pianist George Duke in the 1960s and 1970s. (Carlos Zialcita; photograph by Chuck Gee.)

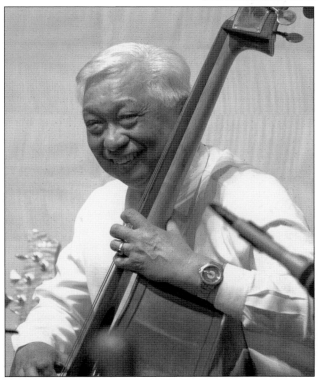

Vince Gomez, a native San Franciscan, is a jazz bassist, music teacher, and conductor who played under the name "Vince Gee" in the 1950s and 1960s in Chinatown's Sky Room. He has taught music from elementary school to college levels for over 30 years. Vince has conducted symphony and chorale groups in major cities around the world. He still plays regularly in the Bay Area. (Photograph by Chuck Gee.)

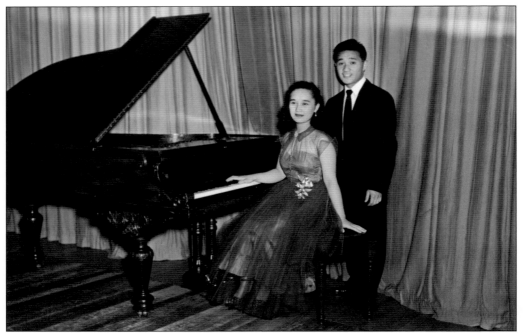

Rebecca Austria was a classical pianist in San Francisco who was well known in the Filipino community. She performed at many concerts, recitals and events. Austria was a piano teacher to many young children whose parents would travel from afar to have their child take lessons. She often accompanied her younger brother, Leonard, at his violin concerts and recitals. (Courtesy of Ellie Hipol Luis; photograph by Alex Hipol.)

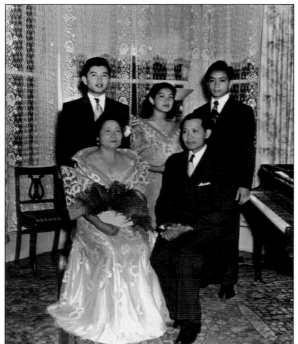

The musically gifted Muribus family included Maria "Lita" Muribus, an accomplished principal harpist; George, a pianist; and Fred, a violinist. Lita played with the New York City Center Opera and the St. Louis Symphony orchestras. She was an advocate of music in the St. Louis public school system and for the disabled community. In this family portrait are (first row) Mr. and Mrs. Muribus; (second row) Fred (left), Lita (center), and George. (Courtesy of Ellie Hipol Luis; photograph by Alex Hipol.)

Prof. Erich L. Weiler's students Leonard Austria (left) and Joseph de Guzman play a duet for violins. This concert was sponsored by the Pacific Musical Club and held at the Forum Club, San Francisco, on February 12, 1949. (De Guzman family; photograph by M. Mondares.)

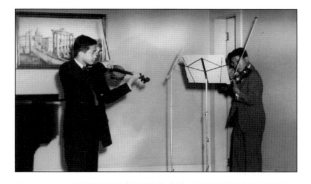

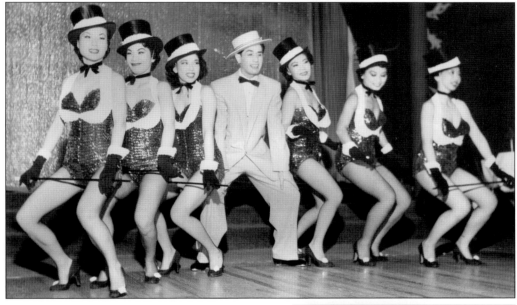

Popular with tourists and celebrities as well as local residents, Chinese nightclubs like Forbidden City and The Sky Room flourished in San Francisco from the late 1930s through the 1960s. The Forbidden City, owned by Charlie Low, featured several Filipino entertainers and dancers including a brother and sister team—Gonzalo Anthony Lagrimas and Arlene Lagrimas, better known as Tony and Arlene Wing. It was common for Filipino entertainers to change their names to gain employment in Chinese clubs. Tony used the name for the rest of his life and remained active as a dance instructor in Chinatown. Above, Tony danced with The Chorines in 1957. At left are performers (from left to right) Arlene Dark, Tina ?, unidentified conga player, Mia Sakamoto, and Beverly ?. (Above, Arlene Lagrimas Dark; left, Trina Robbins.)

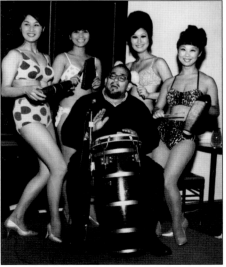

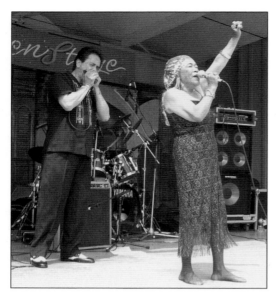

Blues singer Sugar Pie DeSanto (Umpeylia Marsema Balinton), named "Little Miss Sugar Pie" by Johnny Otis and "Little Miss Dynamite" by James Brown, was raised in the Fillmore. Here she's seen performing recently with Manila-born, San Francisco–raised Carlos Zialcita on harmonica. Carlos is also the producer of the annual San Francisco Filipino-American Jazz Festival. (Photograph by Myrna Zialcita.)

Anna Maria Flechero learned to play piano by ear and was inspired by Motown sounds and Latin rhythms of the Mission district. (Courtesy of Carlos Zialcita; photograph by Ellen Gailing.)

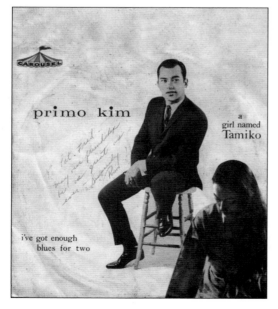

Primo Kim, known as the Asian Sinatra, recorded "A Girl Named Tamiko" for a 1962 film. Primo Villacruz changed his name to fit marquees and get jobs in Chinese nightclubs like the Dragon Lady and the Forbidden City. (Fred Basconcillo.)

The Idols patterned themselves after groups like the Flamingoes and the Orioles. Pictured from left to right, Tito Chavez, Eddie Mendiola, Carlos Chavez, and Norman Ubungen, who met at Everett Junior High School, perform at the San Francisco War Memorial Hall during a Filipino Christmas Benefit Dance in 1961. These young singers later attended Polytechnic, Galileo, and Mission High Schools. (Ubungen family.)

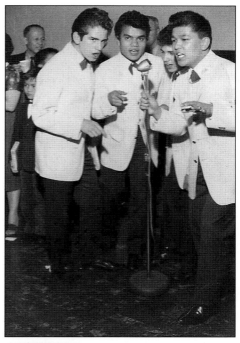

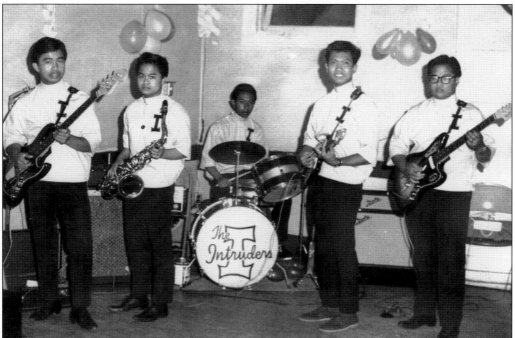

The Intruders, led by Ed Valdehueza, who lived in Bernal Heights, was the first Filipino teenage pop band in 1962. The band played for Filipino and Asian community socials in Seattle, Sacramento, and Los Angeles as well as in the San Francisco Bay Area. They disbanded in 1966. Pictured are the original members—from left to right, Ben Luis, Cesar Valdehueza, Emilio Lugtu, Ronnie Belamide, and Ed Valdehueza. (Ed Valdehueza.)

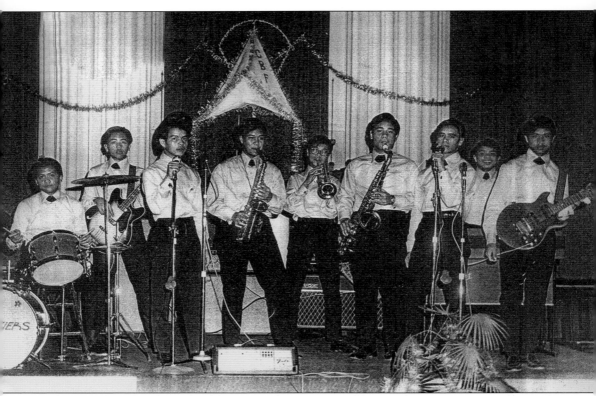

The Mystifiers played for school functions, the YMCA, weddings and private parties, and at Battle of the Bands throughout the Bay Area. They are, from left to right, Phil Nicholas, drums; Phil Ogano, bass guitar; Bobby Seronio, lead singer; Ray Bambao, alto sax; Ed Ocampo, trumpet; Nic Jocson, tenor sax; Bobby Gaviola, singer/drums; Bob Nicholas, keyboard; and Rey Tolero, guitar. Not pictured is the band's manager/agent, Aida Villa. This photograph was taken around 1969 at a Filipino wedding reception at 50 Oak Street. (Courtesy of Arlene Calica-Zamora.)

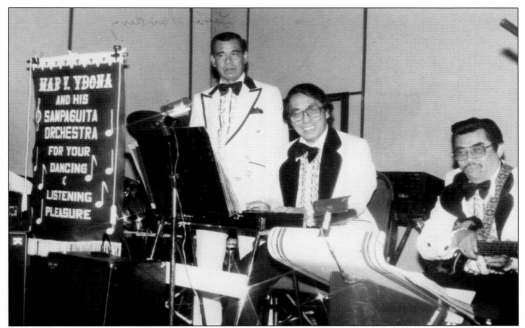

Bandleader Mariano V. Ybona (left) performed regularly with his Sampaguita Orchestra. He is shown here with pianist Nilo Duazo (center) and bass player Ricardo Luib (right). This photograph was taken at the San Francisco Marriott in 1986. (Mars Ibona.)

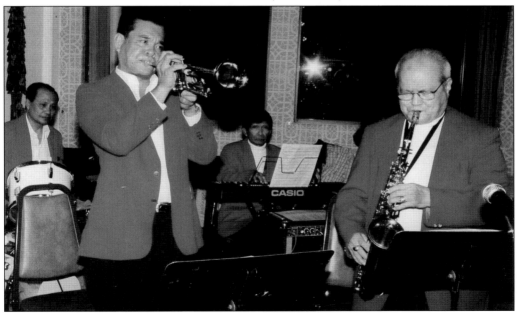

Johnny Rojo, a professional musician, came from Cebu in the 1960s. His band played jazz, rhythm and blues, and traditional Filipino songs for events at the Filipino Community Center, town fiestas, weddings, and special occasions. The band includes, from left to right, Jess Barretto, drums; Eddie Fontecha, trumpet; Benny Arguelles, keyboard; and Johnny Rojo, saxophone. This image was taken at the Christmas celebration at San Lorenzo Ruiz Social Hall in 1997. (Jessie Barretto.)

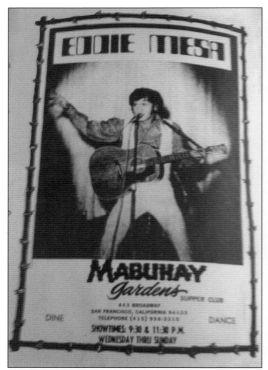

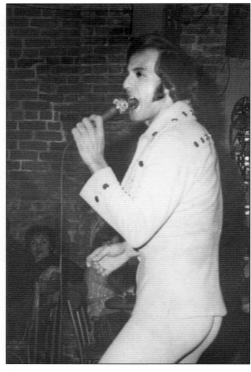

The Mabuhay Gardens, a supper club operated by Ness Aquino in the Caballeros Dimas Alang building, featured many Filipino celebrities from the Philippines, including Eddie Mesa (above), the "Filipino Elvis Presley," and Amapola Cabase, with whom Aquino cohosted a weekly television program called *The Amapola Presents Show* on KEMO-TV, Channel 20. In 1976, Ness Aquino agreed to have rock promoter and television producer Dirk Dirksen book punk and new wave bands there. The Mabuhay Gardens Restaurant by day, The "Fab Mab" became a main venue for punk rock in San Francisco through the early 1980s. Virtually every early Bay Area punk and new wave band performed here, and it was an important touring stop for bands from outside the San Francisco Bay Area. (Above left, San Francisco History Center, San Francisco Public Library; above right, Dalisay Balunsat; right, the Manilatown Archives.)

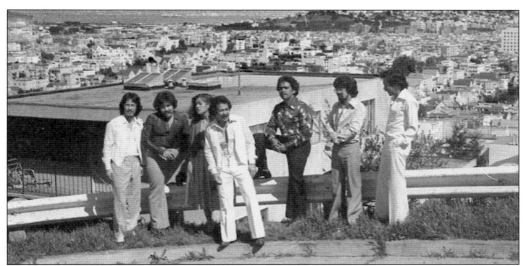

The Geli family lived in North Beach and Nestor, Rudy, and Sibon were known for their musical talents as they played in local bands. Mignon worked with children in Chinatown. Here they are in San Francisco in 1978: from left to right, Kenny Woo, bass; Reynaldo "Ron" Ayala, keyboards; SiBon Geli, vocals; Rudy A. Geli, congas, flute, vocals; Ernie Perez, vocals/percussion; John Benson, drums; and Nestor Geli, guitar. (Sibon Geli.)

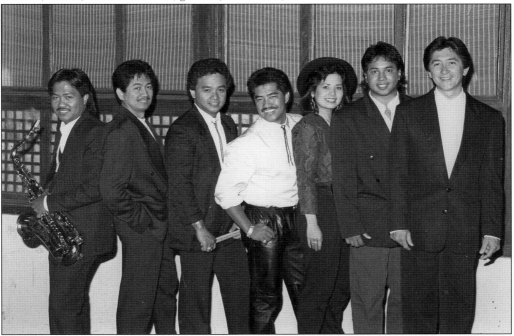

Lily Alunan's performances range from groups doing four-part harmonies to singing solo at the Tonga Room at San Francisco's Fairmont Hotel. She performed with Primetime, a Top 40 dance band, from 1990 to 1996, mainly at private events, association parties, Tito Rey's in South San Francisco, and the Mandarin House in San Rafael. Pictured here, from left to right, are Kiko Mendo, Glenn Redrico, Albert Garcia, Frank dela Rosa, Lily Alunan, Sonny Fortuno, and Mari Casas. (Courtesy of Lily Alunan.)

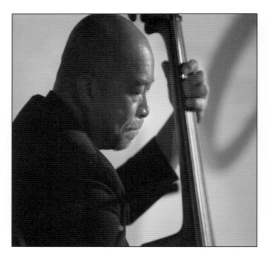
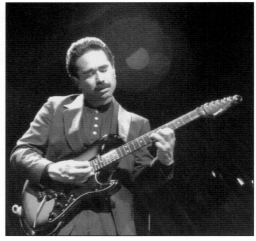

Ben Luis (above, left) played drum and bugle for the American Legion before taking guitar lessons at age nine. Luis is performing here at the 2008 San Francisco Filipino American Jazz Festival. Nito Medina (above, right) studied violin at the San Francisco Conservatory of Music and sang in numerous soul, funk, and Latin rock/jazz fusion bands for two decades beginning in his early teens. He appears regularly at the Tonga Room, Fairmont Hotel, and other local venues. The photograph above right was taken at Lasa Ng Jazz in 1994. The photograph above right was taken at Lasa Ng Jazz in 1994. Melecio Magdaluyo's credits include the Pete Escovedo Orchestra, Carlos Santana, Narada Michael Walden, Chucho Valdez, and Irakere West, Tito Puente, John Santos Machete Ensemble, Jon Jang/Pan Asian Orchestra, Steve Winwood, Bobby Brown, and the Whispers. Percussionist Dana Nunez is in the background but not visible. John Calloway is a multiinstrumentalist, bandleader, educator, and Latin jazz musician. His credits include Israel "Cachao" Lopez, Pete Escovedo, and Max Roach. (Above left courtesy of Carlos Zialcita, photograph by Tony Remington; above right photograph by David Bacon; below left photograph by David Bacon; below right photograph by Lourdes Figueroa.)

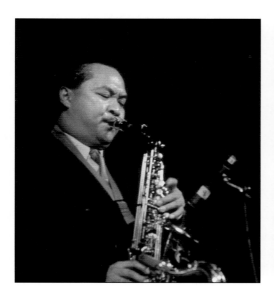
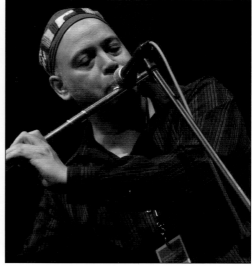

Art Khu, pianist, composer, and educator, started piano lessons at age four and studied classical piano with Sanford Margolis and jazz with Donald Byrd. He is pictured with his protégé Matthew Wong. (Liz Del Sol.)

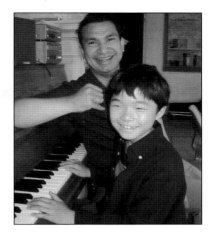

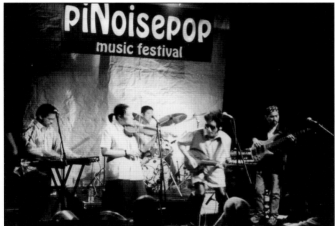

The piNoisepop Music Festival (a playful riff on the Noisepop indie music festival) was founded in 1999 by two brothers, Ogie and Jesus Gonzales, who immigrated to San Francisco from Manila in 1988. The festival featured Filipina/o American and Asian American bands from all over the nation. Here, the band Bobby Bandurria performs at piNoisepop at Bindlestiff in the early 2000s. (Jesus Perez Gonzales.)

In 1997, BAM magazine's features on Q-Bert, Jocelyn Enriquez, and other Filipino American musical artists was their mainstream debut. The 1990s saw an explosion of Filipino American independent music, including punk, indie, alternative, hip hop, soul, R & B, and freestyle. San Francisco natives Q-Bert, a world-renowned DJ, and singer Enriquez were at the top of their games when this issue was published. Other Bay Area acts popular in the late 1990s were Bigg Knutt Funk, Pinay, the bands Love, Daria and Julie Plug, hip-hop dancers Mindtricks, and the DJ crew Invisibl Skratch Piklz. (Courtesy of Dawn Mabalon.)

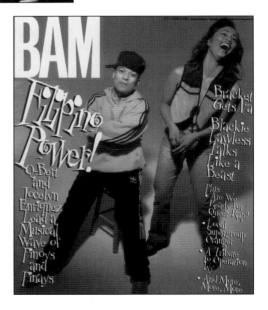

Bagong Diwa (above left), with Alleluia Panis and Gregory Silva (above right), created dance works embodying Pilipino Americans' experiences and inspired by the civil rights movement and Alvin Ailey. At left, from left to right, are (first row) Craig Choi, Luis Gonzalez, Bessie Mar, and Johnson Tom; (second row) Jill Nakashima, Evelyn Ante, Alleluia Panis, and Leslie Watanabe; (third row) Gregory De Silva. Missing from this image are Emilya Cachapero, Gregory De Silva, Leonard Luna, Gloria Tobilla, and Howard Tom. Other members included Cecily Chow, Ray Engler, Betsy Escandor, Victoria Gatchallian, Edna Jundis, Cons Look, Daniel Mabalatan, Mike Magduluyo, Sulpicio Mariano, and Bonnie Yuen. The San Francisco Kulintang Ensemble (below) performed on the back of a flatbed truck on their debut appearance in the San Francisco Carnaval. Following the truck were dozens of musicians and performers from the Fil-Am community tapping traditional ancient rhythms on gongs, drums, and even tin cans. (Alleluia Panis, photograph by Allen Nomura; Robert Kikuchi-Yngojo.)

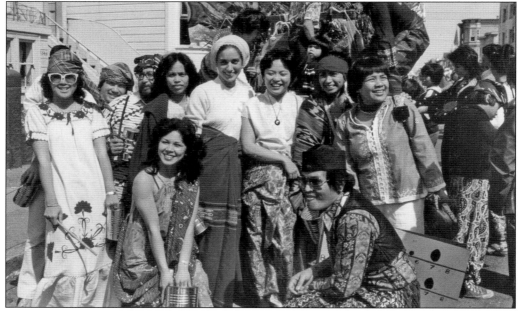

As a boy, Leo Valledor loved to draw and visit the San Francisco Museum of Art. He painted his first serious oils in 1953 while attending the California School of Fine Arts. He then went to New York, joining The Six group. In 1968 he returned to San Francisco and in 1972 began to paint large multipanel color fields. From left to right, friends Domingo Alba, Joaquin Alba, and Sonny Anzano are sitting with Valledor in front of one of his early paintings. (Robert Rosales.)

Carlos Villa is an associate professor at the San Francisco Art Institute and a revered mentor to hundreds of students. His paintings, mobiles, and sculptures are in the collections of Casa de las Americas, Havana, Cuba; Columbia University; the Oakland Museum of California; the Smithsonian Institution; and the Whitney Museum of American Art. Villa's recent exhibits reflect on the life experiences of the pioneer Manong/Manang generation. (Photograph by D. P. Gonzales.)

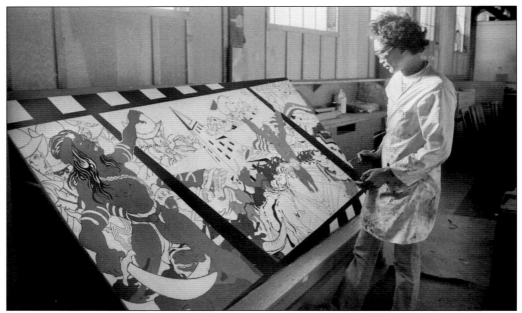

Ed Badajos was known for his political cartoons and visual commentaries. He was the editorial cartoonist for the *L.A. Free Press* and his work appeared in *The Staff*, the *Berkeley Barb*, and in books like *Dick! The Nixon Era* and *Filipino Food*. Badajos gained further exposure through syndication in the underground press of the 1960s and 1970s and through the Kearny Street Workshop. (Photograph by Tony Remington.)

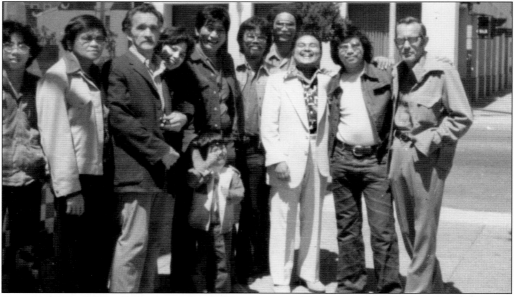

Orvy Jundis and Edna Salaver, members of Liwanag, would scout artistic talent in the Philippines and introduce the work to the United States. In this image are, from left to right, David Salaver, Frank Manano, Sylvester Mateo (painter), Edna Salaver, Alex Nino (cartoonist), Orvy Jundis, Ed Badajos (illustrator), Jesse Santos (cartoonist and radio announcer), Nestor Ocampo, and Ben Davis. (Vidda Chan.)

The Bay Area Pilipino American Writers group (BAYPAW) grew out of the Liwanag anthology around 1974. Usually gathering at Caridad Vallangca's house on Divisadero for eats and readings, conversations and literary discussions, they published two books through Kearny Street Workshop—*October Light*, by Jeff Tagami, and *Without Names*, an anthology. The group includes, from left to right, (first row) Oscar Penaranda, Jeff Tagami, Orvy Jundis, and unidentified; (second row) Presco Tabios, unidentified, Paloma Sales, Jaime Jacinto, Shirley Ancheta, Virginia Cerenio, and Jolina Togonon; (third row) Lenny Limjoco and Laya, Al Robles, Norman Jayo, Aurora Fernandez, Lou Syquia, unidentified, and Pacifico Mortel; (fourth row) unidentified (standing), Victoria Alba, Desiree Penaranda with dog Lucky, Beau Penaranda, unidentified, Vic Rivero Jr., Robert Conway, and Aram Penaranda. (Oscar Penaranda.)

This is a 1976 news clipping about the play *Honeybucket* written by Melvin Dangilan Escueta and directed by renowned author Frank Chin. The playwright, a Vietnam veteran, used the painful lessons of war to better understand and deal with forces which created that war and the delayed stress problems which have affected veterans. (Arlene Escueta.)

Jessica Hagedorn listens to Al Robles reading to an audience—two treasured poet/mentors, *c.* 1999. Trained in theater arts at the American Conservatory Theatre, Hagedorn began writing and reading in San Francisco, authored several novels and plays, garnered numerous awards, and moved to New York in the late 1970s. Robles, who passed away in 2009, was a tireless advocate for the International Hotel, Filipino seniors, and affordable housing and art in all forms. (Robles family.)

Native San Franciscan Pearl Ubungen grew up in the Fillmore District when it was still predominantly African American, neighborly, and filled with music and movement. She danced for years with the late Ed Mock before choreographing her own work and becoming a teacher in her own right. Ubungen's use of alleys and streets to perform her highly dramatic works was an innovative sensation. Her company of dancers and musicians performed throughout the Bay Area and in New York. (Pearl Ubungen.)

Theater Artaud &
Pearl Ubungen Dancers & Musicians co-present

Bamboo Women

Pearl Ubungen
Artistic Director/
Choreographer

in collaboration with
Roberto De Haven
Composer
Kevin Leeper
Sculptural Fabricator
Ken Miller
Photographer
Jose Maria Francos
Lighting Designer

**Summertime
Dance Project**
Theater Artaud
450 Florida Street
San Francisco
Sat. August 13 – 8 pm
Sun. August 14 – 8 pm,
 2 pm Sunday
 Children's Matinee
$12.50 BASS/Ticketmaster;
Tix Bay Area; or call
(415) 621-7797

PHOTO: KEN MILLER DESIGN: ANNE CAMPAGNET

Funding provided in part by California Arts Council and the Zellerbach Family Fund.

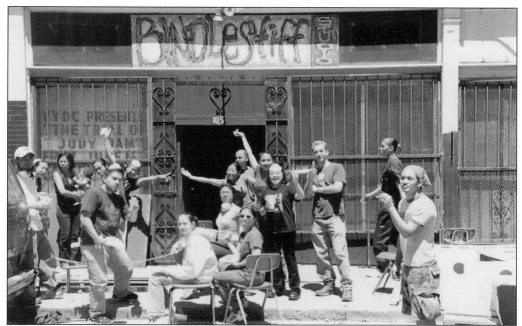

Here, resident artists of Bindlestiff Studio on Sixth and Howard Streets engage in a clean-up day at their theater. The city tore down the building in 2005, and the theater will move back to a new building on the same site in 2011. Resident artists, troupes, and festivals include Tongue in a Mood, Eighth Wonder, the works of playwright Jeannie Barroga, the bands Skyflakes and Bobby Banduria, and the piNoisepop Music Festival. Bindlestiff Theater is the epicenter for Filipina/o American arts—spoken word, theater, sketch comedy, music, and visual art—in the South of Market Area. (Bernadette Sibayan-Rosquites.)

Caroline Cabading, on the *kulintang*, has been a traditional performer since 1991. She studied the indigenous music and dance of Mindanao, Philippines, under Master Danongan Kalanduyan, and toured professionally with the Palabuniyan Kulintang Ensemble. Her performance credits include the San Francisco Ethnic Dance Festival, the National Folk Festival, the University of Hawaii, the University of Alaska, Tufts University, the University of California at Los Angeles and Berkeley, and San Francisco State University. (Ubungen family.)

Jerome Reyes prepares for the art installation Until Today: Spectres of the International Hotel, at the Manilatown Heritage Center on the former site of the International Hotel. The exhibit included video, sculptures made from particles of the actual bricks from the "I-Hotel" foundation, and works on paper. The artist based this work on the history of the Hotel and the epic story of the residents' struggle against eviction, community-based research and a series of conversations with Julio César Morales, and Tammy Ko Robinson. They are in Reyes's studio at Stanford University in May 2010. (Photograph by D. P. Gonzales.)

Three

SPORTS

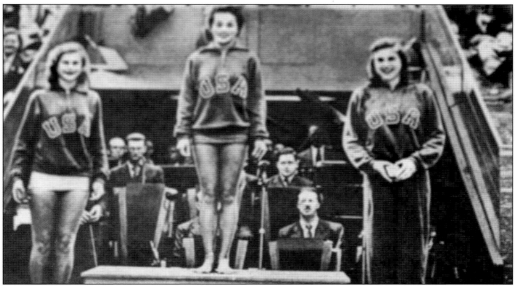

At the 1948 Olympics in London, Victoria Manalo Draves (center) was the first woman in Olympic history to win gold medals in platform and springboard diving competitions—in the 3-meter springboard and the 10-meter platform events. Draves, a native San Franciscan, was the daughter of a Filipino immigrant father and English immigrant mother. In San Francisco, she was not allowed to practice in swimming pools where whites swam—the general racial practice of the time. Coach Phil Patterson of the Fairmont Hotel Swimming and Diving Club noticed Victoria's natural talent and outstanding diving skills. Due to racial discrimination, she was refused pool rights at the Hotel. Patterson established a special club and named it the Patterson School of Swimming and Diving in order for Victoria to train with him and to compete in major events. Victoria is an honoree of the International Swimming Hall of Fame. (Adele Urbiztondo.)

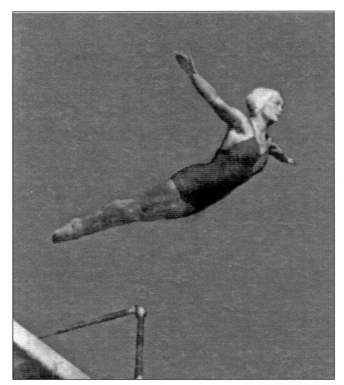

In 2006, the City of San Francisco named a new park in South of Market after Victoria Manalo Draves. As a heroic Pinay and Olympic champion who fought discrimination and beat the odds, she is seen as an important role model to the hundreds of thousands of residents, especially Asian American ones, in the city and county of San Francisco. (Fred Basconcillo.)

The City of San Francisco honored Victoria Manalo Draves with a proclamation presented by mayor Gavin Newsom. Vicki's husband, Lyle Draves, was present at the ceremony. (Fred Basconcillo.)

The incredible performances of Korean American Sammy Lee (left) and Filipina American Victoria Manalo Draves personified the Olympic revival of individual competition regardless of race, creed, or national origin after World War II. Sammy Lee is the first male diver to win back-to-back diving gold medals in platform (1948 and 1952) and won a bronze medal in 3-meter springboard (1948). He went on to coach Olympic champions and become a medical doctor, who patented his own product. (Fred Basconcillo.)

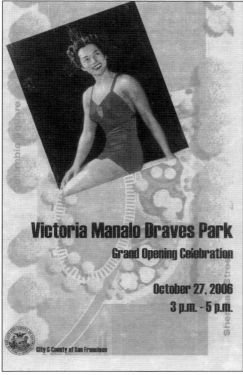

Prior to competing in the 1948 Olympics, Victoria Manalo Draves won five U.S. diving championships. She turned professional after the Olympics, joining Larry Crosby's Rhapsody in Swimtime aquatic show at Soldier Field in Chicago in 1948. She went on to appear in other shows and toured the United States and Europe with Buster Crabbe's Aqua Parade. Draves was elected to the International Swimming Hall of Fame in Fort Lauderdale, Florida, in 1969. (Fred Basconcillo.)

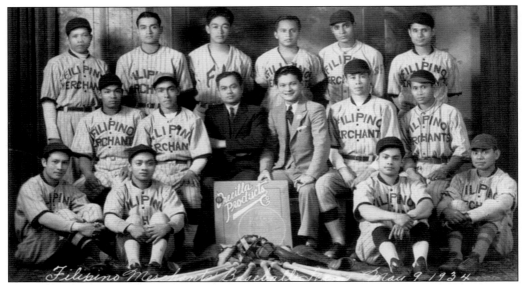

The Filipino Merchants Baseball Team competed against Filipino teams throughout California. Si Ayag, standing behind the man in the dark suit, was on the Mission High School team that won the city championship in 1933. They defeated the Galileo team that had the famous DiMaggio brothers. In that game, Si played first base and hit a shot off the right field chicken wire fence at the old Seals stadium. (Sonny Aranaydo.)

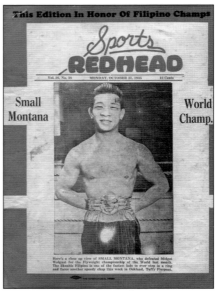

The boxer at left was a high school friend of Lazaro Fabian and could be either Narciso Arcia, Catalino Fermin, Arcadio Banez, or Jose Josue. *Sports Redhead* (right) dedicated its October 21, 1935, issue to Filipino Champs. Small Montana, Young Tommy, Speedy Dado, Pablo Dano, Ceferino Garcia, and Pancho Villa were their names. A write-up inside said, "One thing that we have always said about the Filipino fighters is they are not quitters and they are clean in their ring work. We have yet to see one of the little brown chaps—as they say—dog it." (Left, Larry Fabian; right, Ben Abarca.)

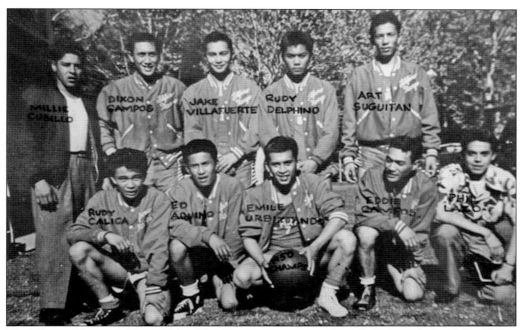

The Filipino Mango Athletic Club of San Francisco was active from 1940 through the 1950s. Young adults competed in various sports and were rewarded with fellowship and lifelong friendships. This 1950 championship Mango basketball team includes, from left to right, (first row) Rudy Calica, Ed Aquino, Emile Urbiztondo, Eddie Campos, and Phil Lazo; (second row) Emilio "Mili" Cabillo, Dixon Campos, Jake Villafuerte, Rudy Delphino, Art Suguitan. (Adele Urbiztondo.)

The Filipino Youth League (FYL) in San Francisco was created in the Central YMCA for Filipino American boys and girls from 12 to 23. After the first year, the club expanded to 60 members, who participated in picnics, skating parties, dances, and athletics. Activities taught good leadership and citizenship skills for the community. (Calica family.)

Written on this photograph is, "To Mr. and Mrs. Collado and Family, Remembrance from Nicoleta and Patricia Padua." (Henry Collado.)

Winners of the Champion Metro Swim Meet in April 1951 at the Buchanan YMCA, this team did not have its own swimming pool and had to go across town to practice at the Chinatown YMCA. Robert Rosales (second row, third from left) was a proud member of that team. Their coach was a Mr. Paine. (Robert Rosales.)

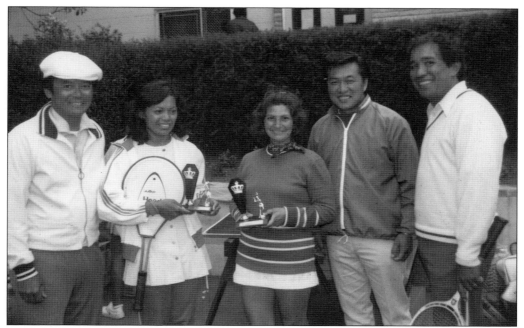

The Filipino Tennis Club of Northern California was established in 1936 by Marcos Silvestri just one year after the Manila Tennis Club of Pasadena was formed by Aquilino Monsod. In 1937, an intense tennis rivalry ensued, with the northerners winning the first three annual matches. Tournaments played in San Francisco were held at public courts in Golden Gate Park, McLaren Park, Dupont, Mission Dolores, Mid-Town Terrace, and Mountain Lake. (Above, Fred Basconcillo; below, Ralph Yngojo.)

Urbano Tejo's consistent words to his students were, "Never forget who you are and where you come from." A prominent member of the Filipino community, Tejo was known as a martial arts practitioner and member of the Filipino Masonic lodge. In 1961, he started his training at 1819 Market Street in San Francisco under Prof. Duke Moore, and it was here he brought his three children—Arturo, Fernando and Lenore—with him to learn the martial arts. Lenore continues this long-standing family tradition. Below, One of Tejo's earlier dojos was in Hunters Point Naval Shipyard where a diverse community of Raza, Filipinos, Asians, whites, and blacks lived and played and learned. Sensei Tejo is kneeling far right and Lenore his daughter standing far left with her husband Frank Gaviola extreme left. (Frank and Lenore Gaviola.)

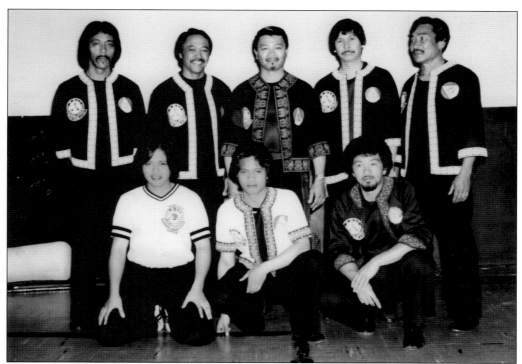

Filipino martial arts are known as Eskrima, Arnis de Mano, and Kali. Ben Largusa is the sole grandmaster of the Villabrille-Largusa system of Kali. His main teacher was Floro Villabrille, who fought and won the last death match in Hawaii in 1948. Largusa was his only student and has taught in the San Francisco Bay Area since the 1970s. In the photograph above, from left to right, are (first row) Lindsey Largusa, Jerry Largusa, and Greg Lontayao; (second row) Eustaquo "Snookie" Sanchez, Tony Lamadora, Ben Largusa, Mel Lopez (current Tuhan), and Greg Rojas. In the image below, Prof. Manny Dragon poses with students he teaches in Daly City. Guros and professors train and drop by, along with regular guest Eskrimadors at Dragon's classes. Here are some guros and professors along with their students. (Largusa family.)

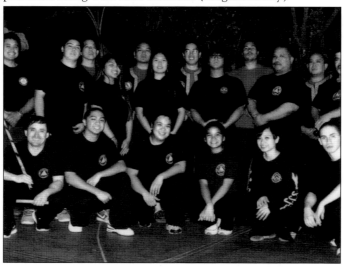

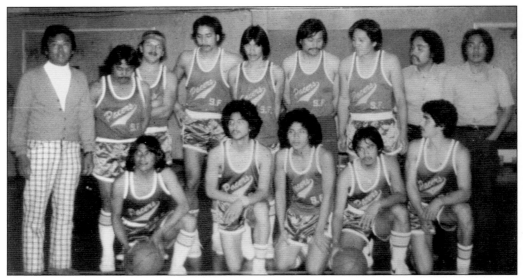

The tradition of Filipino American sports teams is often continued by college students and alumni. The majority of the Pacers were from SF State University. Several of these team members would go on to finish advanced degrees and become lifetime educators. Left to right: front row, Dennis Ubungen, Marc Yngojo, Willie Vallejo, and unidentified; back row, Ralph Yngojo (coach), Robert de Guzman, George Cousart, Glenn Tigno, Ray Cordova, Oscar Penaranda, Steve Arevalo, Edgardo Kabahit. (Oscar Penaranda.)

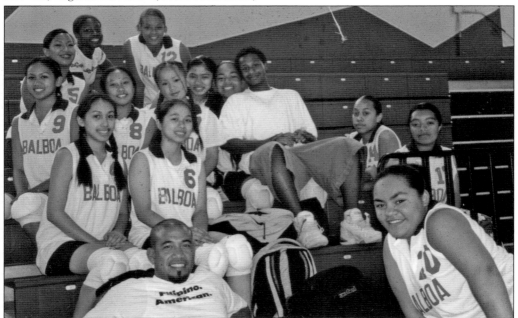

Val Tintiangco-Cubales (lower left) is an award-winning teacher and the athletic director at Balboa High School. He also serves as the head coach for varsity girls' and boys' volleyball and varsity boys' basketball. Originally from Santa Cruz, he competed in basketball and volleyball. Val also teaches and competes in Brazilian Jiu Jitsu and is one of the first Filipinos to receive his black belt from the world-renowned Gracie Academy. He is an avid, lifelong surfer. (Allyson Tintiangco-Cubales.)

In 2006, Lorenzo and Florentino Ubungen proudly hold their trophy as Washington High School defeated Lowell High School, winning the section A1 championship game at AT&T Park, home of the San Francisco Giants, 2010 World Series Champions. Lorenzo and Florentino continue to play in league baseball in Cebu, Philippines. (Ubungen family.)

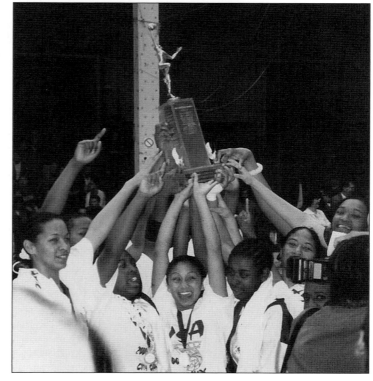

Julia Ubungen, Lorenzo and Florentino's older sister, played on the International Studies Academy team that won the City Championship of San Francisco Girls High School Basketball at Kezar Pavillion over Washington High in 2001. (Ubungen family.)

San Francisco Giants pitcher Tim Lincecum (left) and Manny Pacquiao boxer pose at Giants Stadium. Filipino American Tim Lincecum was the Cy Young Award winner for 2009, and world-famous Filipino boxer Manny Pacquiao was the featured guest and threw the first pitch at the Filipino Heritage Night in 2009 for the game between the Giants and the Padres, with 42,000 in attendance. (San Francisco Giants.)

Ana Julaton was born at St. Lukes Hospital, resided in the Tenderloin district, and attended Bessie Carmichael school until fourth grade. Ana "The Hurricane" Julaton is a World Boxing Organization (WBO) and International Boxing Association (IBA) Superbantamweight World Champion, the first to ever unify the world championships. She is the first in the history of professional boxing to accomplish this feat in only seven professional fights. (Ana Julaton.)

Four

POLITICS AND EDUCATION

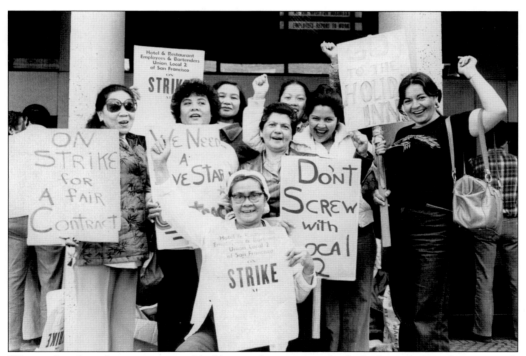

Women hotel workers are pictured holding picket signs, one of which reads "Don't screw with Local 2." Filipinas and Latinas were among the labor activists and leaders of organized labor on strike in 1980. Large numbers of Filipinos are employed in the hospitality and food service industries of San Francisco. The rank-and-file demonstrated solidarity with workers of all racial and ethnic backgrounds, employing tactics that were as creative as they were aggressive in addressing wage, benefits, and work condition issues. (San Francisco Labor Archives and Research Center, SFSU.)

Pictured around 1946, Carlos P. Romulo (left) was press director and a brigadier general under Gen. Douglas MacArthur during World War II, the first non-American to win the Pulitzer Prize in Correspondence, in 1942; co-writer and signator to the original United Nations Charter in San Francisco; president of the Fourth Session of United Nations General Assembly, 1949 to 1950; chairman of the United Nations Security Council; and Philippine ambassador to the United States beginning in 1952. (San Francisco History Center, San Francisco Public Library.)

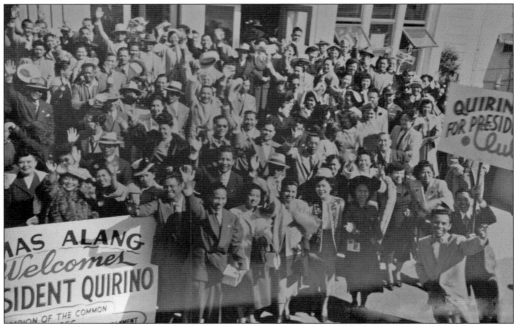

Members of the Caballeros de Dimas Alang crowd await President Quirino at San Francisco International airport (SFO) in the early 1950s. (Courtesy of the San Francisco History Center, San Francisco Public Library.)

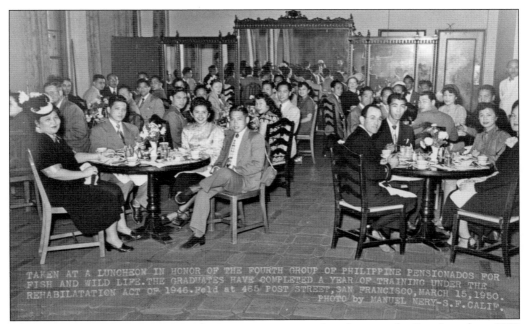

The Philippines sent many waves of government supported students to the Bay Area from 1902 until just after World War II. Held in March 1950, this luncheon was in honor of the fourth group of Filipino *pensionados*. This was the fourth group of *pensionados* studying for Fish and Wildlife preservation and development. (San Francisco History Center, San Francisco Public Library.)

The community welcomed consul Jose Imperial in 1950 while the realization of long-desired national independence in 1946 was yet new.(San Francisco History Center, San Francisco Public Library.)

Members of the City College of San Francisco Filipino Club are pictured in 1951. From left to right are (first row) brothers Bart and Bernard Regino; (second row) Tony Martinez, Charles Bevien, Manuel Luna, Carlos Idelfonso, Jerry Suarez, Ben Sanchez, and Olympio Galon. (Liban family.)

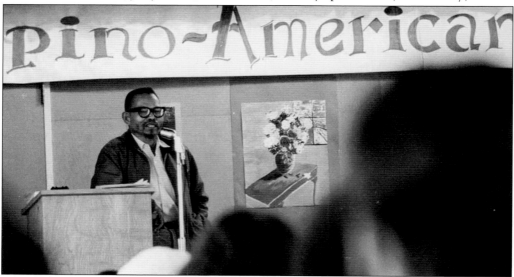

Legendary farm labor organizer Larry Itliong was a founder of the Agricultural Workers Organizing Committee (AWOC) that initiated the farmworkers' strikes at Coachella Valley and Delano in 1965. Later that year, AWOC merged with the National Farm Workers Association to form the United Farm Workers Organizing Committee, with Cesar Chavez, which became the United Farm Workers Union (UFW) that launched the Delano Grape Strike of 1965. Itliong is speaking at one of the first Filipino Youth Conferences in the nation held at Bessie Carmichael School in the South of Market neighborhood in the early 1970s. (Photograph by D. P. Gonzales.)

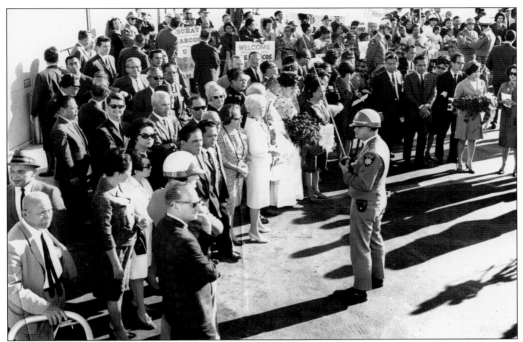

Mutya Ng Silangan and crowd await President Marcos at SFO in May 1969. At the time, President Marcos enjoyed broad popularity in the Republic of the Philippines and among the Philippine diaspora. (Abriam family.)

The left image shows Juanita Tamayo on the picket line on January 13, 1969. The student-led strike at SF State brought global attention to student and faculty activists and the violent police suppression authorized by then governor Ronald Reagan, mayor Joseph Alioto, and SFSC president S. I. Hayakawa. Philippine American Collegiate Endeavor (PACE) were early members of the Third World Liberation Front and cofounders of the first School of Ethnic Studies. (Juanita Tamayo-Lott.)

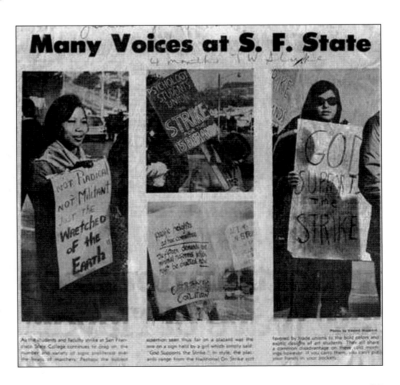

Founders and members of the Philippine American Collegiate Endeavor, PACE, are pictured after a political discussion with President and Ms. Marcos. The two—en route to the state funeral of former president Dwight D. Eisenhower in 1969—were at the height of their pre-martial law (1972) global popularity. From left to right are (seated) two unindentified women, Orvy Jundis, Ferdinand Marcos, Imelda Romualdez Marcos, Robert Ilumin, and Edward Delacruz; (standing) Daniel Phil Gonzales, PACE founder Patrick Salaver, and Ronald Evans Quidachay. (Quidachay-Swan family.)

The Pilipino American Collegiate Endeavor (PACE) was engaged in the student-led strike at San Francisco State in March 2, 1969. Donald Castleberry, dean of graduate studies, signed an agreement to hire a full-time Filipino American academic advisor in 1972. From left to right are Ben Zambales, Tony Grafilo, Andy Caceres Alex Miguel, Mae Dumpit, Rolando Laureto, William Tamayo, Oscar Penaranda, Bill Orlando, Tony Guiuan, Danilo T. Begonia, Bayani Mariano, and John Foz. (Oscar Penaranda.)

Academic advisor Albert Reyes joined SF State in 1974, the first counselor of Filipino ethnicity at the college (now university). The national search that brought him to the campus was a direct response by the administration of Pres. S. I. Hayakawa to aggressive political action by PACE and support from Asian American Studies, Ethnic Studies, and student organizations. Reyes worked with thousands of students, during his career of over 30 years until his retirement. (Reyes family.)

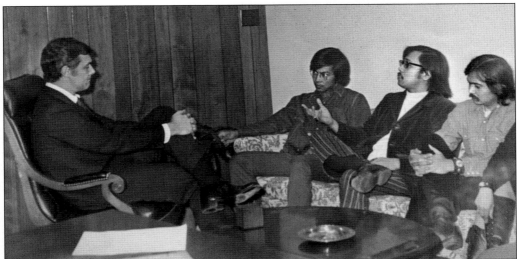

In this *c.* 1971 photograph are, from left to right, George Moscone, Edward Ilumin, Rev. Antonio Ubalde, and Serafin Syquia. Rev. Antonio Ubalde, of Glide Memorial Methodist Church, was president of the United Filipino Association, an advocacy group for the International Hotel community in the late 1960s and early 1970s. Serafin Syquia and Edward Ilumin, both SF State alumni, were involved with a government-funded research project working out of the International Hotel. George Moscone, a California state senator well known for his attention to underserved people, offered support. (San Francisco History Center, San Francisco Public Library.)

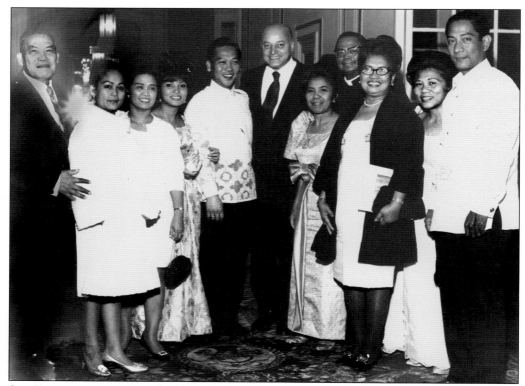

San Francisco mayor Joseph Alioto, sixth from left, stands among community leaders from Northern and Central California in this c. 1970 photograph. Alex Fabros Sr. is at the far left (San Francisco History Center, San Francisco Public Library.)

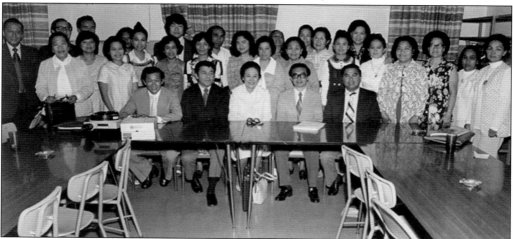

In the 1970s, the Filipino community rallied to build the Filipino Education Center (FEC) in the SoMa district to meet the academic, social, and emotional needs of newly arrived immigrant children. In the 1980s, the school district closed down the FEC. Filipino community activists, teachers, and parents fought back and were able to restore the center. Their efforts continued and Bessie Charmichael/FEC extended its services from kindergarten to eighth grade. FEC is also the home for the afterschool program, Galing Bata. (M. C. Canlas.)

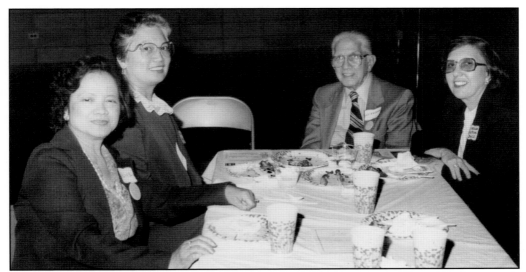

State commissioner Alice Bulos (far left), a revered Filipino community political leader, attends a Filipino American Democratic Club (FADC) function. Third from left is Jess Esteva, publisher of *The Mabuhay Republic,* a Republic Party member, and major political leader with strong ties to Sen. Dianne Feinstein since her early political years as San Francisco supervisor and mayor. (D. P. Gonzales.)

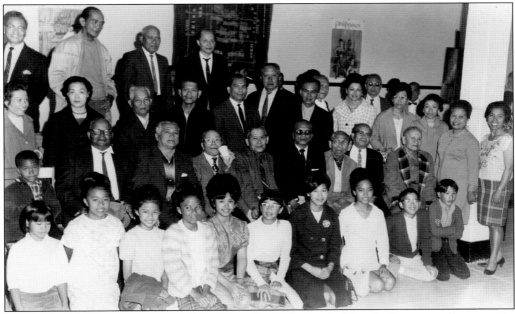

Mrs. Asuncion and Panlibutan and Mrs. Pasculetti, who worked for the Economic Opportunity Council, organized meetings such as this to motivate Filipino community action on senior housing and health care issues like those on Kearny Street. Bill Tamayo, in the 1970s a student activist, said, "They were community workers who saw the bad living conditions, including lack of heat, and made complaints to the city. The city in turn complained to the landlord, and Mrs. Panlibutan turned to students at UC Berkeley and San Francisco State to help the *manongs.*" (Panlibuton family and William "Bill" Tamayo.)

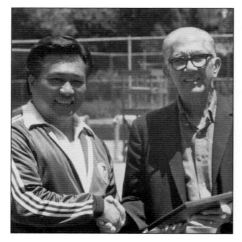

"Uncle Fred" Basconcillo and Jess Esteva, two powerful political leaders at the tennis courts in Golden Gate Park. Esteva, publisher of the *Mabuhay Republic* newspaper, a powerbroker within the Filipino American community, had the ear of leading politicos. His family business, Esteva Travel, was a major sponsor of the Filipino Tennis Club of Northern California. By virtue of his political acumen, Tennis Club cofounder "Uncle Fred" rose from apprenticeship to the Presidency of the Ironworkers' Union and the national board of the AFL-CIO against strong racial prejudice. Basconcillo was a very early advocate to the official recognition by the athletic community and general public of the achievements of Olympian Victoria Manalo Draves.

Purisma Salazar and the United Pilipinos for Equal Employment (UPEE), represented by the fledgling Asian Law Caucus (ALC), won a historic class action employment discrimination lawsuit against Blue Shield of California. Equal Employment Opportunity Commission attorneys had earlier refused to take the case. This signal victory demonstrated both the need for private, nonprofit legal services and the high quality of Asian Law Caucus legal and political skills. (Faye Pollack.)

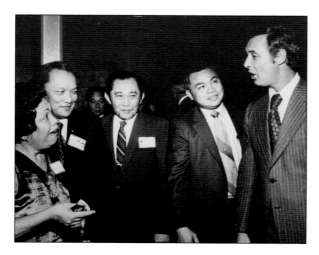

California state senator George Moscone, a liberal Democrat, chats with several San Francisco community leaders in the early 1970s. Moscone would gain a reputation for appointing well-qualified racial minorities, women, gays, and lesbians to government and civil service posts in unprecedented numbers. He kept close relations with the Filipino American community. The mayor delivered a moving eulogy at the funeral of Julita T. McLeod just before his own tragic end in 1978. (San Francisco History Center, San Francisco Public Library.)

Agripino Richard Cerbatos, an engineering business owner, and Ronnie Avenida, businessman, were leaders of the Filipino American Democratic Club of San Francisco. High-quality pulic education was a supreme tenet of the group, which had strong representation of educators and health and service professionals in its membership. Cerbatos was the first Filipino to serve on the San Francisco Board of Education in the 1980s. (Photograph by D. P. Gonzales.)

The establishment of the Filipino Education Center (FEC) in the South of Market was the result of effective community organizing and advocacy by Filipino teachers and parents in the 1970s. The FEC was dedicated to addressing the academic, social, and emotional needs of newly arrived immigrant children. Due to the adverse budgetary effects of Proposition 13/Article 13a, the San Francisco Unified School District closed the FEC in the early 1980s. Filipino activists, teachers, and parents again fought to restore the Center. Their persistent efforts resulted in the improvement and expansion of Bessie Charmichael/FEC from an elementary school to K–8. The recently constructed FEC is also the home of the much-lauded afterschool program, Galing Bata. (M. C. Canlas.)

Students from UCB, UCLA, and community workers meet. In 1968 the owners of the International Hotel served their tenants eviction notices. Residents staged a public protest outside the hotel that drew attention from local college students and the local community. This began the antieviction movement to save the International Hotel and provide for decent low-cost housing for low-income seniors. At left, Wahat Tompao, outspoken resident of the International Hotel, and Calvin Roberts, vice president of the International Hotel Tenants Association, speak at an event. Below, students from Los Angeles and the San Francisco Bay Area meet about the living conditions in the International Hotel and the antieviction movement. This photograph includes activists Gil Carrillo, Bill Sorro, Pete Almazol, Bill Lee, Emil DeGuzman, Dan Figueracion, Liz del Sol, and Estella Habal. (Left, Calvin Roberts; below, Estella Habal.)

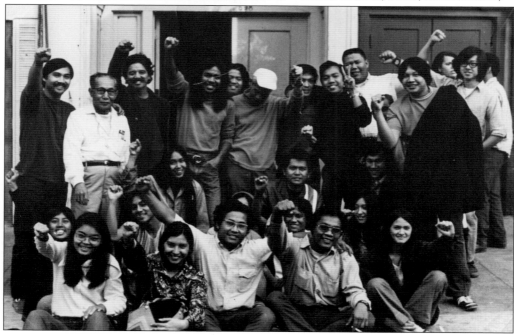

Joaquin Legaspi was a quietly inspirational International Hotel (I-Hotel) resident and anti-eviction leader—a profoundly principled and humble mentor to those whom he felt were honest and true. He operated a small appliance repair shop but was a fine painter—in realist, modernist, postmodernist, and abstract styles—poet, scholar, teacher, and a masterful chess player as well. He was one of the most articulate members of the United Filipino Association, precursor to the International Hotel Tenants' Association. He's walking past one of the several Filipino restaurants along Kearny Street in the early 1970s. (D. P. Gonzales; photograph by Danilo T. Begonia.)

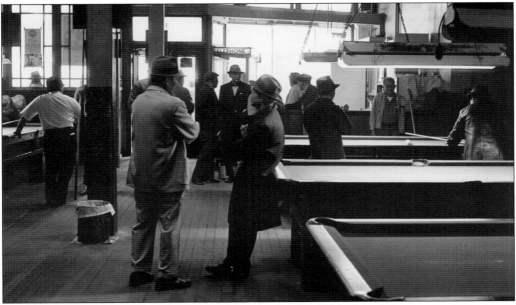

Pool halls are traditional gathering places for men, and the Lucky M across from the I-Hotel was the last in Manilatown on Kearny. (Manilatown Heritage Archive; photograph by Chris Huie.)

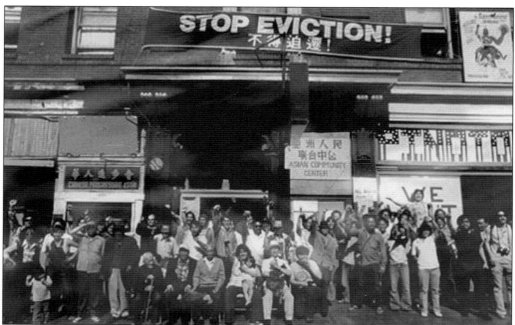

The movement against eviction from the I-Hotel and for affordable public housing gained immediate support from a broad base of San Francisco social and political activists in 1968. The Hotel's street level commercial spaces were the nexi for pan-Asian American artistic, literary, social service, and political groups, including the Kearny Street Workshop, the Manilatown Senior Service Center, and the Chinese Progressive Association. The "Stop Eviction" banner that hung above the hotel entrance and "We won't move!" were the movement rallying cries. Below, the assembling of the human barricade of resistance on the night of the eviction, August 4, 1977. An estimated 3,000 people surrounded the building while residents and supporters stayed inside until they were forcibly removed by sheriffs' deputies and the fire department. (Above, Chris Huie; below, Belvin Louie.)

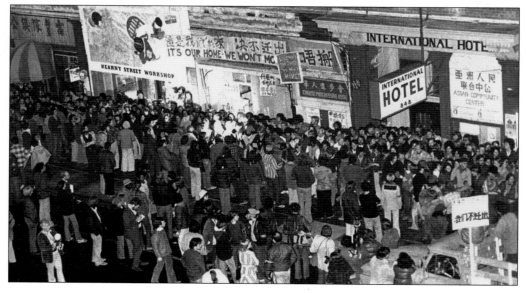

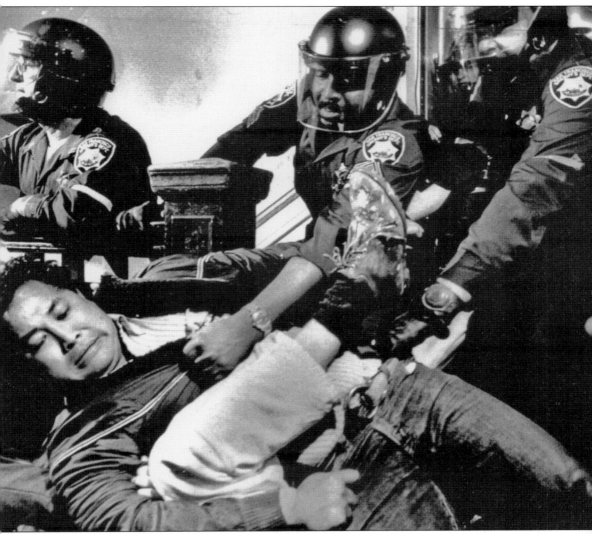

On the night of the eviction, tenants from the International Hotel and community supporters barricaded themselves in the building, sitting in the hallways in peaceful protest. San Francisco Sheriff's Department deputies removed each person one by one. Emil DeGuzman, president of the International Hotel Tenants Association, is shown passively resisting removal as officers begin to drag him down the stairs and into the street. Demolition of the hotel began a year later, with an empty hole remaining for over 20 years. (Emil DeGuzman.)

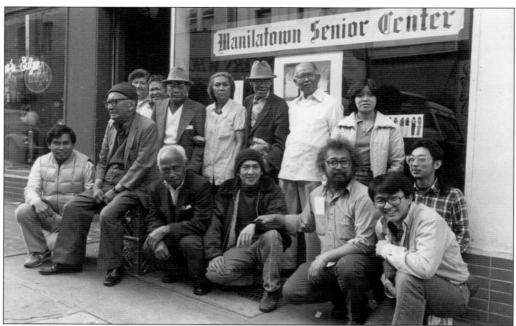

In 1981 the Manilatown Senior Center was located at 636 Clay Street. Margaret Muyco, site manager at the time, said that seniors would go there to watch television, talk with friends, play bingo, or engage in arts and crafts projects. Funds needed to be raised for the planned permanent location for the center at the Clayton Hotel. One fundraiser was Casino Moon Night, to be held at 640 Pine Street. Above are Antonio Sarfino, Margaret Muyco, Benny Milano, Tony Remington, Jose Coloma, Al Robles, Legardo, Jean ?, Manuel Soria, and a Mr. Pascual. Below, Jean ? and her coworker serve lunch to the seniors. (Above, Robles family, photograph by Chris Huie; below, Manilatown Archives, photograph by Belvin Louie.)

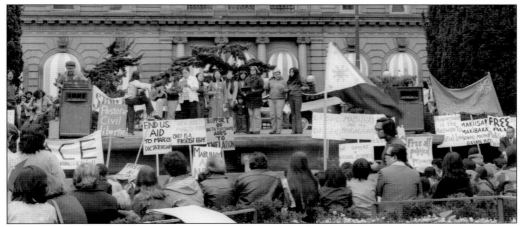

Members of the Katipunan ng mga Demokratikong Pilipino (KDP), a militant anti-Marcos organization, sing at a *c*. 1978 anti-Marcos rally in Union Square. They are, from left to right, Melinda Paras, Nora de Leon, Sorcy Rocamora, Christine Araneta, Cynthia Magalaya, Ruby Howing, Marcela Pabros, Terri Bautista, Nena Hernandez, and Annatess Araneta. (Estella Habal, photograph by Rick Rocamora.)

Frank Magsino, renowned painter; Tomas Concepcion, Rome-based sculptor; and Antonio "Tony" Garcia, manager of the Caballeros de Dimas Alang House—now the San Lorenzo Ruiz House—are pictured at an anti-Marcos meeting at the home of author Caridad Concepcion Vallangca. The meeting, attended by several other Marcos resisters, was a major element of what would become the Ninoy Aquino Movement. (Photograph by D. P. Gonzales.)

Mayor Diane Feinstein (first row, right) poses with a Filipino women's group at an informal house gathering around 1980. Identified in this photograph are community leader Lorraine Wiles (first row, left) and (second row) Pearl of the Orient members Lily Santos (fourth from left) and Tony Santos (sixth from left). (Abriam Collection.)

Ronald Evans Quidachay was sworn in as the second Filipino American member of the California bench on January 2, 1983. In this image are, from left to right, *Philippine News* publisher Alex Esclamado; Lou Mitra Esclamado; Katharine Swan, the new judge's spouse; Judge Quidachay; commissioner Wayne Alba; California Supreme Court associate justice Cruz Reynoso; Timothy Dayonot, a staffer from the office of Gov. Jerry Brown; Antonio Garcia Jr.; and Antonio "Tony" Garcia. (Photograph by D. P. Gonzales.)

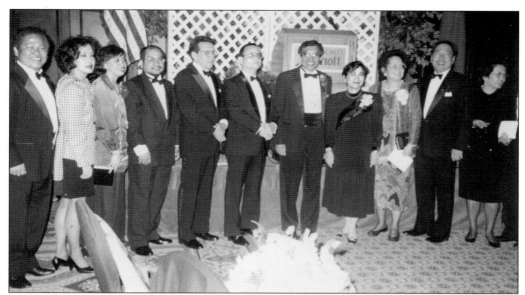

Attending a Philippine Press Club event around 1992 are, from left to right, Greg Macabenta, unidentified, Eva Betita, Pep "Red" Vasquez, Johnny Collas, Dennis Normandy, consul general Alfredo Almendrala, Alita Almendrala, Tessie Marzan, Rodel Rodis, and Lupita Aquino Kashiwahara. (Pep "Red" Vasquez.)

Officers of Filipino Educators in San Francisco, from left to right, Remy Anselmo, Maria Luisa Penaranda, Ligaya Avenida, and Shirley Dimapilis attend a banquet dinner for Filipino American Educators Association of America conference in San Francisco around 1995. Maria Luisa was hired as a Filipino bilingual kindergarten teacher at Filipino Education Center. (Maria Luisa Penaranda.)

Tessie Guillermo (left) poses with her sister Pauline Guillermo-Togawa (center) and Jill Guillermo-Togawa. In a public statement for "Let California Ring," Tessie said, "Having a public acknowledgment of their commitment is important in our culture. Jill and Pauline's marriage has strengthened us as a family unit. We always considered Jill a member of the family, and now we can legally acknowledge her as such. We've always embraced their relationship. They are very constant and loving parents to our niece Carmel, and because their union is recognized in California, it creates a very strong social fabric for our family. We need to celebrate that." (Pauline Guillermo and LetCaliforniaRing.org.)

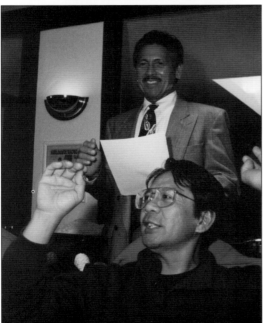

Joe Julian (left image, standing), seen here with Prof. Danilo T. Begonia of Asian American Studies at SF State, learned academic discipline, core values of family, community, social justice, and civic engagement at Morning Star School. He also became dean of the College of Behavioral and Social Sciences from 1986 to 1995 and then the first university dean for Human Relations from 1995 to 1997 at San Francisco State University. In 1995, Bill Tamayo (right) became the regional attorney for the U.S. Equal Employment Opportunity Commission in San Francisco. (Both photographs by D. P. Gonzales.)

Julita Tamondong McLeod (left) was an elementary school teacher who became the first Filipino school principal in the San Francisco Unified School District. She was a political powerhouse and advocate for quality public education who supported the establishment of the Filipino American Studies program in the Asian American Studies Department at SF State in 1969. The late Helen Toribio (right) was an instructor in Asian American Studies at San Francisco State University and at City College of San Francisco. As an activist scholar, she dedicated her life to immigrant and civil rights issues. She coauthored *The Forbidden Book: The Philippine-American War in Political Cartoons*, edited *Seven Card Stud with Seven Manangs Wild*, and contributed to *Legacy to Liberation* and several Asian American publications. (Rod McLeod and Allyson Tintiangco-Cubales.)

The sisters of Kappa Psi Epsilon pose with their advisor, Allyson Tintiangco-Cubales, a professor at San Francisco State University, during a Pinayism workshop. Gayle Romasanta took the initiative to create a sisterhood at Cal State Long Beach in 1996, and Kappa Psi Epsilon was born. Since then it has expanded to San Francisco State University; University of California, Davis; and University of California, Los Angeles. (Allyson Tintiangco-Cubales, photograph by Ruby Del Remedio.)

These graduates from San Francisco State University in 2000 are, from left to right, Ruben Pimentel, Jolina Barsanti, Amelia Bustos, and Jeniffer Delafosse. (Jolina Barsanti.)

When demolition of the entire structure of the International Hotel was completed in 1979, the resulting half-block hole in the ground remained empty for more than two decades while advocates for low-income housing wrangled with landowners and politicians. Members of the Filipino-American fraternity Chi Rho Omicron at San Francisco State University helped organize the ground-breaking ceremony and festivities for the new International Hotel, a low-income senior housing building that opened on August 26, 2005. (Chi Rho Omicron Archives.)

On March 24, 2009, parents and activists are holding a large banner reading "Education is Our Human Right" at the March for Education—and against budget cuts. (Jasper Pugao.)

Pin@y Educational Partnerships, founded by Allyson Tintiangco-Cubales in 2001, is a teaching pipeline that has created a "partnership triangle" between the university, public schools, and the community to develop critical educators and curricula at all levels of education and in the community. Uniquely, this pipeline implements a transformative decolonizing curriculum and pedagogy with primary, middle, secondary, postsecondary, and graduate students. (Verma Zapanta.)

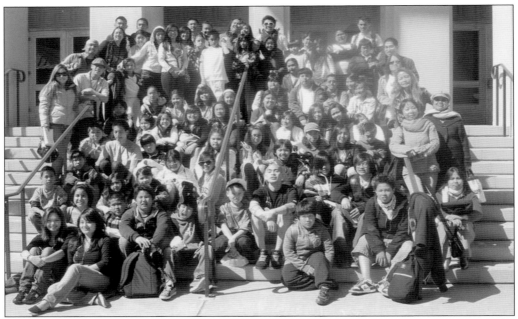

Rich in cultural diversity, Bessie Carmichael School/Filipino Education Center is a treasure in the heart of the South of Market Area (SoMa). Its nurturing, loving, and caring campuses are home to programs that focus on the development of the whole child. Now a K-8 school, it offers programs designed to provide interactive and hands-on learning for students. (Maggie Deguzman.)

On February 23, 2010, the San Francisco Board of Education unanimously passed a resolution to institutionalize ethnic studies for high school students. Community organizations PEP, PODER, POWER, CCDC, FCC/ALAY, and Coleman Advocates worked in concert with teachers and parents to support ethnic studies. Teachers including Kyle Beckham, Aimee Riechel, David Leong, Artnelson Concordia, and Pete Hammer collaborated directly with Allyson Tintiangco-Cubales, a professor at SF State, to create the curriculum. (Photograph by Aldrich Sabac.)

Five
REFLECTIONS

Robert Rosales, Al Robles, and Bill Sorro grew up together in the Fillmore with many other Filipinos. Family names in the neighborhood include Delfino, Alba, Quilala, Verador, Campos, Cerbatos, Reposar, Valledor, Basconcillo, Aquino, Yngojo, Aquino, Ramos, Domingo, Austria, Landag, Nicolas, Matulac, Manalo, Suguitans, Castaneda, San Felipe, Tolibas, Amaril, Cabillo, Delosada, Urbiztondo, Revilla, Alfafara, Calica, Maun, Dakiwag, Bocar, Suarez, Valentie, Ubungen, Liban, Palpolato, and Bautista. Robert, Al, and Bill attended parties at the Iloilo Circle, joined the Mangos basketball team, and often partied at Jimbo's Bop City, Black Hall, Jackson's Milk, and 500 Club in Fillmore on weekends from Friday through Sunday. Robert became a carpenter; Al studied philosophy at the University of San Francisco, and Bill supported six children with a job as an ironworker. (Guilliana Sorro.)

Philippine *veteranos* of World War II ride in formation, preparing for a Veteran's Day parade. Under a 1990 reversal of the 1946 recission of citizenship and benefits to World War II Philippine military and bona fide guerilla veterans, tens of thousands of Philippine veteranos immigrated to the United States. The Veterans Equity Center (VEC), headquartered in the Bayanihan Center on Mission Street in SOMA, has been fighting for full equity benefits for World War II veterans since December 1999. The VEC offers linguistically competent and culturally appropriate services to veteranos and their immediate families living in San Francisco. In 2009, Pres. Barack Obama signed a law that provided partial benefits. (M. C. Canlas.)

Philippine World War II veteranos receive recognition for their service and their struggle for equity from Filipino American students at the University of San Francisco. (Joaquin Jay Gonzalez.)

Morning Star School, founded by priests of the Order of Divine Word and run by nuns from the Belgian order Daughters of Mary and Joseph, had dedicated teachers who stressed personal discipline and academic basics. Sr. Mary Agnes appreciated the rich diversity (blacks, Filipinos, Japanese, Latinos, whites) of the student body. Above are alums/attendees at the 50-year reunion in 2007. (Joe Julian.)

Many of these SF State Strike veterans and friends were involved in creating the School (now College) of Ethnic Studies. Some served on the Third World Liberation Front (TWLF) Central Committee, and others on the Asian American Studies Planning Group. Tamayo-Lott taught in the original Asian American Studies program and staffed the office of the first dean of the School of Ethnic Studies, Jim Hirabayashi. Attending the 40th anniversary of the Ethnic Studies program—the first such institution in the nation—from left to right are (first row) Dee Kaala Carmack, Jim Hirabayashi, Kathy Swan, and Ron Quidachay; (second row) Rosalie Alfonso, Sandy Mori, Penny Nakatsu, Bill Tamayo, Judy Nihei, Jeff Mori, Anita Sanchez, Juanita Tamayo-Lott, and Ellie Luis. (Juanita Tamayo-Lott.)

The Filipino American Arts Exposition of 1994 was a right-brained child of Carlos Villa and Oscar Penaranda. It included a film and video festival, theater performances, education and literary events (panels discussions, speakers, presentations), displays of artwork, and a parade coordinated by Marialuisa Penaranda. Lenny Limjoco designed the logo, among other artistic contributions. Luz De Leon was the first director. The Pistahan Festival became the main event for the Arts Expo, an annual event held at Yerba Buena Gardens, now led by Al Perez. (M. C. Canlas.)

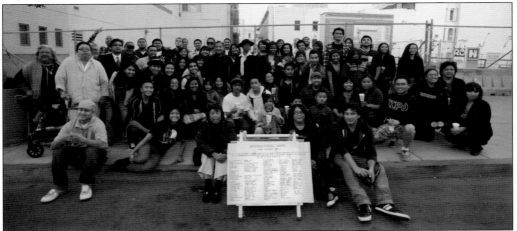

"Stop the eviction! We won't move!" was the battle cry for community and labor organizations during the antieviction movement. Every year on August 4, people gather for a commemoration of the eviction with a candlelight procession, music, performances, speeches, and a reunion. Former activists, housing rights advocates, students, descendents of former tenants, and social justice advocates for the poor attend the annual event. Long live the I-Hotel. (Gerard Lozano.)

Community leaders, families, and youth founded the Filipino Community Center (FCC) in the Excelsior district in December 2004. The FCC offers programming and services for the entire community. It aims to provide a safe space where Filipino families can access services, meet, and hold activities to improve the collective capacity of the community. FCC fosters commitment and responsibility to each other, the community, and larger society. (Terry Valen.)

The International Hotel Manilatown Center offers senior residents many activities, including bingo, karaoke, movies, gardening, a legal clinic, and social services. On holidays, the elders share food and music at parties with family and friends. (MHF archives.)

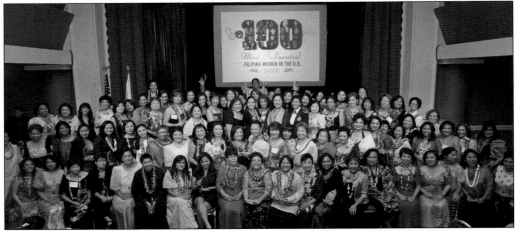

Filipina Women's Network's (FWN) mission is to enhance public perceptions of Filipina women's capacity to be leaders. FWN produces Eve Ensler's *The Vagina Monologues* in its campaign to end domestic violence. The 100 Most Influential Filipina Women in the U.S. Award honors Filipina women who are changing the face of power in America, have reached status for outstanding work, and have been recognized for their leadership and achievements in the U.S. workplace and communities. (Filipina Women's Network.)

On April 4, 2003, students at San Francisco State University unveiled the Filipino Community Mural. The mural is an amazing collaborative effort painted by 200 students, faculty, staff, and community members that depicts the struggles and solidarity of Filipinos in both the United States and the Philippines. (Allyson Tintiangco-Cubales.)

Bindlestiff Studios presented *The Return of the Bakla Show: Myths Retold, Realities Unfold* in June 2010 to educate, challenge, and encourage dialogue among and between different ethnic and sexually diverse communities by means of increasing the visibility of the Filipino American LGBTQQI (lesbian, gay, bisexual, transgender, queer, questioning, intersex) experience through theatrical stage performance. This production exclusively presented and explored the extraordinary and mundane experience of individuals who reflect the distinct influence of being Filipino American and queer. (Ann Borja.)

M. C. Canlas (far left) regularly leads historical tours of San Francisco landmarks with Philippine or Filipino American importance. This group stands in front of the Dewey Monument, dedicated in 1902 to commemorate U.S. victory over the Spanish fleet at Manila Bay on May 1, 1898. On June 12, 2010, coinciding with the celebration of the declaration of Philippine independence in 1898, the local Filipino American community installed on the base of the monument a plaque that more accurately described the war as a colonial venture of the United States. (M. C. Canlas.)

The San Lorenzo Ruiz Senior Citizens Housing Center, formerly the Caballeros de Dimas Alang (CDA) House, home to mostly Filipino elders, is bordered by streets named after Tandang Sora, Lapu Lapu, Mabini, Rizal, and Bonifacio—all heroes of the struggle for Philippine freedom and national democratic independence. The street naming was achieved by the efforts of the CDA fraternal organization that cofounded the House with the Tenants and Owners Development Corporation (TODCO). (Photograph by Aldrich Sabac and Jeffrey Lapitan.)

On the east side of the Caballeros de Dimas Alang/San Lorenzo Ruiz House, the majestic mural *Ang Lipi ni Lapu Lapu*, eight stories high, features scenes from Philippine and Filipino American history. Painted by Johanna Poethig, Prisco Tabios, and Vicente Clemente in the mid-1980s, the mural is a powerful representation of the enduring presence and influence of Filipino Americans in San Francisco. Black-and-white does not do justice to this beautiful mural. (Photograph by Aldrich Sabac and Jeffrey Lapitan.)

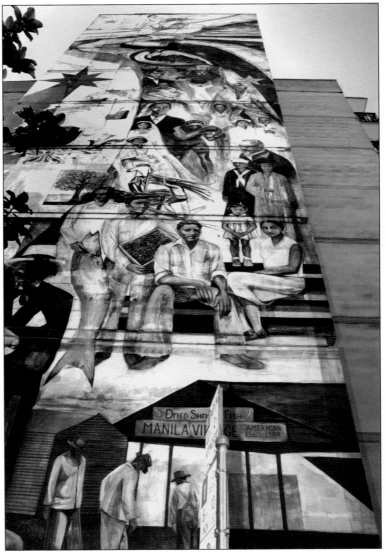

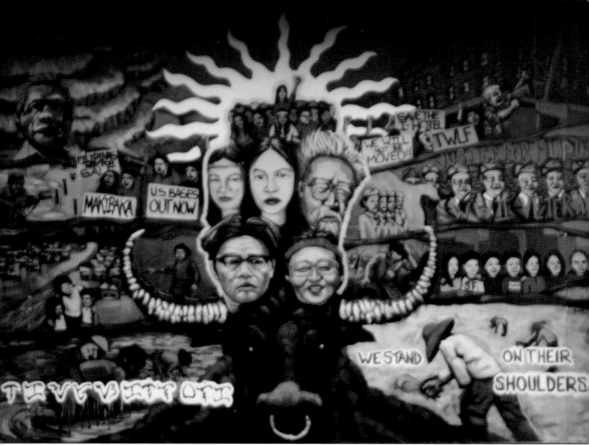

On April 4, 2003, students at San Francisco State University unveiled the Filipino Community Mural, which depicts the struggles and solidarity of Filipinos in both the United States and the Philippines. It was an amazing collaborative effort painted by 200 students, faculty, staff, and members of the San Francisco Bay Area community. Again, black-and-white does not do justice to this mural. (Allyson Tintiangco-Cubales; photograph by D. P. Gonzales.)

www.arcadiapublishing.com

Discover books about the town where you grew up, the cities where your friends and families live, the town where your parents met, or even that retirement spot you've been dreaming about. Our Web site provides history lovers with exclusive deals, advanced notification about new titles, e-mail alerts of author events, and much more.

Find *Your* Place in History.